IMAGES
of America

PLACER COUNTY

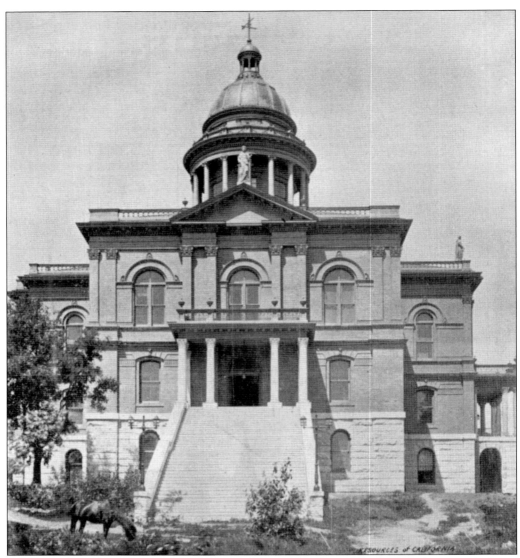

This is the earliest photograph found by the author of the Placer County Courthouse in Auburn. Construction was started in 1894, and the building was dedicated in July 1898. This image comes from the front cover of a June 1897 magazine titled *Resources of California*. Therefore, this photograph was taken a full year prior to the dedication of the courthouse. The outside of the courthouse looks finished, so work on the interior must be all that remained to be completed during the final year of construction between the summer of 1897 and the summer of 1898. (Courtesy of author.)

ON THE COVER: It looks like everyone in this photograph was posing for the photographer. The train has stopped at the Southern Pacific Railroad station to take on passengers in the small community of Applegate in Placer County. This photograph was taken just a few years after the "cab forward" locomotives were introduced on the route over Donner Summit. This photograph is on a postcard from the author's personal collection. The full image can be seen on page 51. (Courtesy of author.)

IMAGES
of America

PLACER COUNTY

Arthur Sommers

ARCADIA
PUBLISHING

Published by Arcadia Publishing
Charleston SC, Chicago IL, Portsmouth NH, San Francisco CA

Printed in the United States of America

Library of Congress Control Number: 2009928331

For all general information contact Arcadia Publishing at:
Telephone 843-853-2070
Fax 843-853-0044
E-mail sales@arcadiapublishing.com
For customer service and orders:
Toll-Free 1-888-313-2665

Visit us on the Internet at www.arcadiapublishing.com

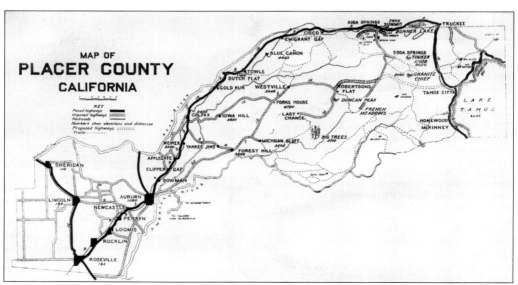

Above is a copy of a Placer County map taken out of a *c.* 1925 pamphlet. This map shows many of the communities depicted in this book. (Courtesy of author.)

CONTENTS

ACKNOWLEDGMENTS

I received a lot of help in writing the captions for the images in this book, and I also borrowed quite a few images from organizations and from people I know. Jim Johnson Photography of Grass Valley was the source for 5 images; the Society of California Pioneers was the source for 3 images; Dana Scanlon loaned me 4 images from his collection; I borrowed one image from Kathleen Warwick-Duncan; and I used 19 images from the Placer County Museums Division's wonderful collection of Placer County photographs.

Members of the Colfax Area Historical Society helped me with the facts in the captions for the Colfax area images. Helen Wayland of Colfax was particularly helpful and patient with my questions. Phoebe Astill of the Roseville Historical Society helped with the information in the captions for the Roseville images. Doug Ferrier of the Golden Drift Museum in Dutch Flat helped with the Dutch Flat, Alta, and Towle captions. Mike Moffet reviewed the Forest Hill Divide images for me. Leonard Davis checked the wording on captions for the Roseville and Rocklin area photographs. Davis has had many of his own books published on Placer County history.

George Riechman reviewed an early draft of the book to provide insight and comments by someone not familiar with Placer County history. Carmel Barry-Schweyer, recently of the Placer County Archives, provided valuable assistance by reviewing an entire draft of the book's manuscript to help with the overall history of Placer County. Barry-Schweyer has two of her own Arcadia publications covering aspects of Placer County history.

Images used in this book that were not provided by persons or organizations listed above came from my own private collection of Placer County real photographic postcards, photographic prints, and paper collectibles, such as the receipts used on page 47 and 123, the envelope shown on page 53, and the wanted poster on page 124.

Finally, I would like to thank Helen Learn for writing the book's introduction.

INTRODUCTION

Placer County is long and narrow, extending from the city of Roseville at the eastern edge of the Sacramento Valley and curving to the northeast up over Donner Summit to the northwestern shores of Lake Tahoe, a change in elevation of over 7,000 feet. Placer County is roughly bound by the Bear River on the northwestern edge, and the wild Rubicon River establishes much of the southern border. The American River and its tributaries meander through most of the county's center. Moving west to east, the landscape changes from the flat valley floor, up through the oak-studded rolling hills of the Sierra Nevada foothills, into mixed forests with deep canyons cut by the rivers, and on to the granite peaks of the Sierra Nevada. As is true of many locations in Northern California, Placer County owes its existence to the California Gold Rush that began with the discovery of gold in January 1848 at Coloma, not far from present-day Placer County. The word "placer" comes from the Spanish word *placera*, referring to loose sand and gravel containing gold and gemstones. Placer County history is directly related to its geology, its abundant resources, and its climate. The lay of the land lent itself to the location of the route of the transcontinental railroad, the Lincoln Highway, U.S. Highway 40, and Interstate 80 through the heart of the county, which also greatly contributed to its growth and prosperity.

For thousands of years before gold was discovered at Coloma, the Nisenan Indians—the native inhabitants—lived in harmony with the land and its resources. Their way of life disappeared within a few years after the onslaught of gold seekers. At the time gold was first found in Coloma, California technically belonged to Mexico, although it was under American military rule as a result of the ongoing Mexican-American War. California was officially ceded to the United States in February 1848 with the passage of the Treaty of Guadalupe Hidalgo. Due to the rapid increase in population as a result of the Gold Rush of 1849, and amidst the debate over free states and slave states, Congress declared California a "free-labor" state as part of the Compromise of 1850. California became the 31st state in September 1850. With statehood declared, 27 counties were defined. Placer County was not among those original 27, but by April 1851, Placer County was carved out of portions of two of the original counties—Sutter and Yuba—because of the continuing expansion in population.

The California Gold Rush began the moment James Marshall spied an oddly colored shining stone in the American River when he was overseeing the construction of a sawmill for his employer, Gen. John Sutter. Marshall's heart must have beat a little faster when it occurred to him that this might be gold. Sutter confirmed Marshall's finding was gold indeed. Sutter was hoping to keep the discovery a secret at least until his sawmill was completed. That did not happen, though, as it was too big a secret to be contained for very long. Two weeks after the initial discovery in January 1848, word got out, and by that spring, fortune seekers, mostly from settlements in California and Oregon, were headed to Coloma. Sutter not only lost his mill workers to "gold fever" but his workers at his fort in Sacramento and the laborers from his farm on the west bank of the Feather River as well. President Polk confirmed the discovery of gold in an address to Congress

in December 1848, and by the beginning of 1849, waves of immigrants from all over the world converged upon California. In the beginning, for those lucky enough to arrive quickly, the gold was easily panned from gravel in the streambeds. Claude Chana, a French immigrant working on a ranch near the Bear River, was one of those lucky ones: on his way to Coloma in the spring of 1848, he found gold in the Auburn Ravine, located in what became Placer County. His find was said to be the first gold discovery in Placer County.

By 1850, the "easy pickings" from streambeds were mostly gone. There was still plenty of gold, but it was increasingly harder to find and harder to extract. Gold seekers began to turn to more complicated methods to extract the gold, including hydraulic and hard-rock mining. This required formation of companies with the need for capital and heavy equipment. Many individuals concluded that the dream of making an easy fortune in gold was not realistic, and many of them opened stores to serve the miners' needs or built sawmills to provide lumber for the mines. They carved out roads and opened hotels and law offices. They purchased land, built homes, planted crops and orchards, and built schools and churches. In other words, they set about the business of building communities. Fortune seekers may have come to Placer County for the gold, but many of them stayed because of the other abundant resources and opportunities they found in the county.

One of those abundant resources was timber. Numerous sawmills started up all over Placer County. Great quantities of lumber were needed first to service mining needs and later to supply lumber for the construction of the Central Pacific Railroad. One of the most successful lumber companies in Placer County was the Towle Brothers Company. Allen Towle traveled from Vermont in 1855 to find gold, but like so many others, he envisioned different opportunities more to his liking. He set up his first sawmill in Blue Canyon in 1859. By the late 1860s, Allen Towle and his two brothers (George and Edwin) founded the town of Towle, near Alta, along the path of the Central Pacific Railroad. In Towle, they manufactured wood pulp for paper. Over time, the brothers had many sawmills in the area and built a narrow-gauge railroad to bring lumber from the forests to their mills. At its peak, Towle had a store, town hall, church, hotel, depot, and school. Most of the buildings in Towle were gone by the time Interstate 80 was constructed, and today all that is left of Towle is a bend in the track and a cement pad that might have been the foundation of the train depot. Coincidentally, the author of this book, from his birth in 1950 until age five, lived with his parents and three older sisters in the converted Southern Pacific depot at Towle. The train no longer stopped at Towle at that time. The author's father was the Southern Pacific's signal maintainer for the stretch of track in that area.

Another of Placer County's abundant resources—water—also played a large part in its history. During the Gold Rush, ditches were constructed to bring water to dry areas to aid with washing gold out of the gravel. Ditch companies were formed, and as mining declined, these ditches were used to supply irrigation water to the growing agricultural community. Today the system of canals and ditches is maintained by the Placer County Water Agency and the Nevada Irrigation District. Residents can still purchase "miner's inches" of water for irrigation purposes. Over the years, there have been many dams and reservoirs completed to control the water resources in Placer County. Construction of the Auburn Dam on the American River began in 1967 but was halted in 1975 because of earthquake concerns. Just recently, the river was restored to its natural course after having been routed through the diversion tunnel below Auburn for the past 30 years.

The building of the transcontinental railroad—that great technological feat of the 19th century—had a profound effect upon the growth of Placer County. The route that Theodore Judah plotted through the Sierra Nevada went up the northern edge of the county. Many of the towns and points of interest mentioned in this book owe their existence to the commerce generated by the construction of the railroad and the work camps or stations created by the Central Pacific Railroad along the rail line.

With the automobile gaining popularity during the first decade of the 20th century, there was a push to develop a coast-to-coast roadway. The Lincoln Highway was dedicated in 1913 to meet this demand. The portion of it that traveled through Placer County followed the Donner Pass Road and various other mountain roads that parallel present-day Interstate 80. The Lincoln

Highway passed through Emigrant Gap, Colfax, Weimar, Applegate, and Auburn and wound down through Newcastle, Loomis, Rocklin, and Roseville. Later the road was realigned in some places and renamed U.S. Highway 40. Some of the points of interest represented in this book were a result of commercial establishments sprouting up along the Lincoln Highway and U.S. Highway 40. With the Highway Act of 1956 came the construction of Interstate 80, and eventually U.S. Highway 40 was decommissioned.

The climate in Placer County is especially conducive to growing grains and many types of fruit trees: for a time, Placer County was called "The Fruit Basket of the World." The fruit-packing sheds are still standing in Loomis, Newcastle, and Colfax and today house businesses and retail stores. There is still a very lively agricultural community in Placer County, providing fresh produce to local markets and to the year-round certified farmers' markets. One of the unique events that attracts visitors to Placer County every fall is the Mountain Mandarin Festival, which celebrates the harvest of the county's Owari Satsuma mandarin oranges.

The excellent climate, the easy accessibility via train and interstate freeway, and those same abundant resources that originally made this area a good home to the early settlers continue to draw visitors from around the world. They come to partake of the extensive water resources— to enjoy swimming, boating, white-water rafting, kayaking, and even gold panning. There are fantastic bike, hiking, running, and horse trails, many world-class golf courses, cross-country and downhill skiing, and endurance sports events. These are the things that most visitors learn about Placer County.

Arthur Sommers's previous Arcadia Publishing book, *Auburn*, took the reader on a visual tour of the county seat of Placer County. This new book is about the wider territory of Placer County. Using his personal collection of old and rare photographs, Sommers presents a combination of the familiar and the lesser-known features of the county. It is Sommers's hope that readers of this visual history will be inspired to explore the beautiful and diverse region that is Placer County, California.

—Helen Learn

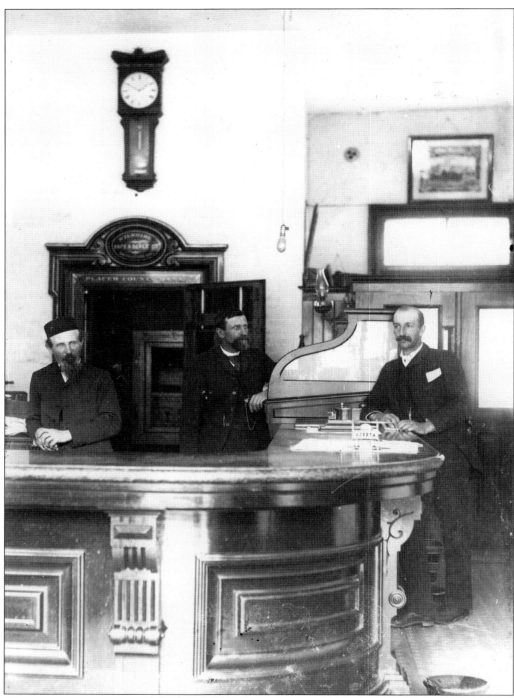

Above is an interior view of the original Placer County Bank, which opened in Auburn in 1887. The bank vault door can be seen behind the men posing at the bank's service counter. The vault door is long gone; however, the metal frame for the vault door is still there inside the modern business that now occupies the old bank location at 345 Commercial Street in Auburn, California.

One

WESTERN PLACER COUNTY

Images in this first chapter are of towns and small communities located in the western part of Placer County. This part of Placer County is a geographical area located on the flat floor of the great Central Valley of California. The Central Valley of California extends from the city of Redding in the north to the city of Bakersfield in the south. This over 450-mile-long valley drained by the Sacramento and the San Joaquin Rivers has long held claim as one of the greatest agricultural centers on earth. Communities in the western part of Placer County include Lincoln, Loomis, Penryn, Rattlesnake, Riego, Rocklin, Roseville, and Sheridan. The different communities will be grouped according to their proximity to each other and generally listed moving from west to east from the most extreme southwest corner of Placer County heading east into the foothills of the Sierra Nevada. This chapter starts with the unincorporated community of Riego, which is located on the border of Placer and Sutter Counties. Riego is in the most extreme southwest corner of Placer County.

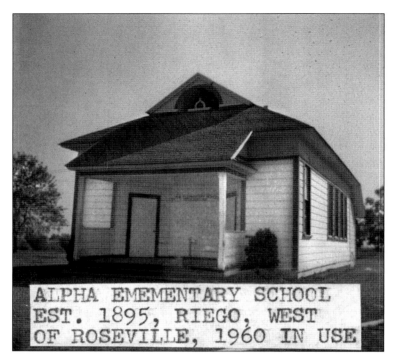

This one-room schoolhouse served the small community of Riego for many decades during the first half of the 20th century. The school building was finally torn down in the 1960s. Riego is located on a small peninsula of land sticking out of the most extreme southwestern portion of Placer County. (Courtesy of Placer County Museums Division.)

ALPHA EMEMENTARY SCHOOL EST. 1895, RIEGO, WEST OF ROSEVILLE, 1960 IN USE

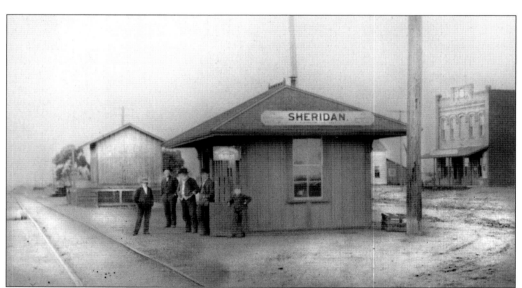

A picture of the Sheridan depot confirms its location on the Southern Pacific Railroad's main line north to Oregon. Even the smallest communities located along the main lines and on the interurban rail lines had depots, as both people and goods relied heavily upon railroads for transportation. (Courtesy of Placer County Museums Division.)

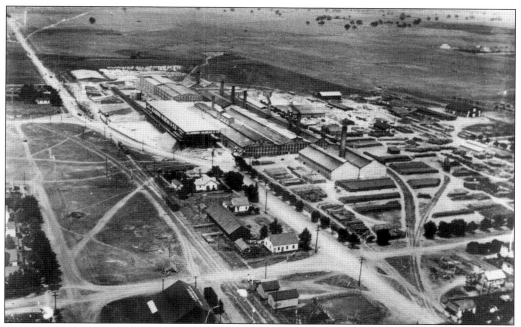

An early aerial view of the large Gladding McBean and Company plant shows some of the town of Lincoln built up around the plant. In the distance at the top of the image can be seen the flat land, which was well suited to the growing of grain crops.

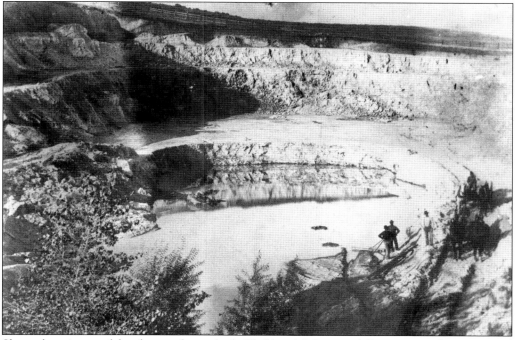

Shown here is one of the clay pits from which Gladding McBean and Company workers extracted the high-quality clay used in the making of water and sewer pipes and terra-cotta decorations for building facades.

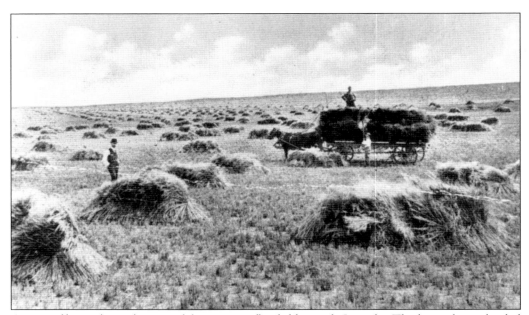

A crop of hay is being harvested from a very flat field outside Lincoln. The hay is being loaded onto a wagon to be brought into the town of Lincoln.

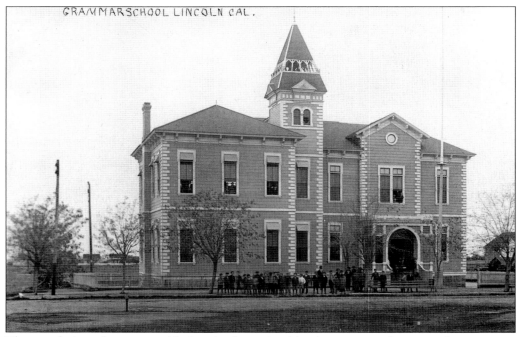

GRAMMAR SCHOOL LINCOLN CAL.

The population of a town could often be determined by the corresponding size of its grammar schools. The Riego school shown on page 12 of this book would indicate a very small population, while the size of the Lincoln Grammar School shown here indicates a much larger population.

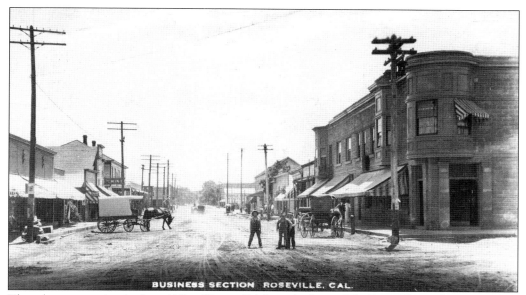

BUSINESS SECTION ROSEVILLE, CAL.

Three boys are posing in the middle of Roseville's Lincoln Street. The Roseville Banking Company bank building with the rounded turret-like corners is on the right. This spot is at the intersection of Lincoln and Church Streets looking south down Lincoln Street.

LINCOLN ST. BRIDGE ROSEVILLE.CALF

Looking north on Lincoln Street, the First Presbyterian Church in Roseville sits just across the bridge over Dry Creek. This building still stands at the corner of Lincoln Street and Linda Drive, but it now houses the Salvation Army.

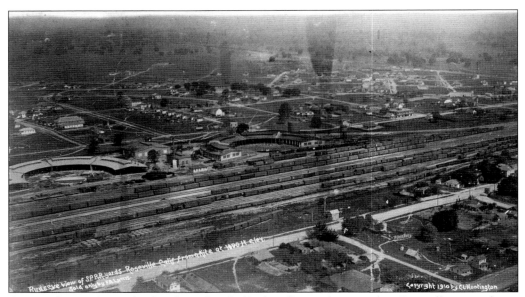

An aerial view shows the Southern Pacific Railroad's switching yard in Roseville soon after it had been relocated from Rocklin to Roseville. Two railroad roundhouses can be seen in this photograph, which was probably taken in 1910 from an early airplane. Each roundhouse had 32 stalls for locomotives.

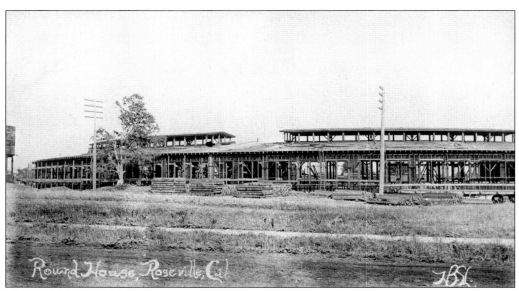

This photograph shows the first one of the two 32-stall roundhouses under construction. Roundhouses allowed the parking of many engines all pointing to a central turntable, which enabled yard crews to easily turn the massive engines around.

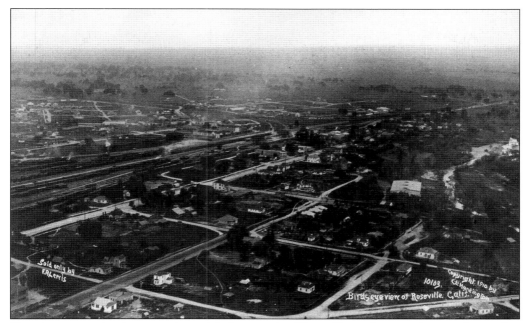

Here is a companion image to the aerial photograph of Roseville on the opposite page, but in this image, the camera has panned right just a little to get the area farther east. The pair of photographs shown here at the top of pages 16 and 17 was taken in 1910. Though the Wright Brothers made their maiden aeroplane flight only seven years prior to these photographs being taken, these images were probably taken by a camera in an airplane and not from a balloon.

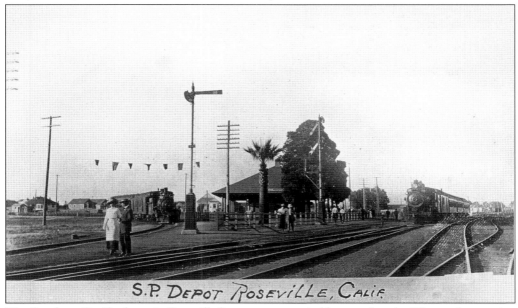

The Southern Pacific depot in Roseville lies among a myriad layout of tracks. The tracks running off to the left in this image are the main line north to Oregon, while the tracks running off to the right are the main line to Utah. Roseville's original name was Junction because of the crossing of Southern Pacific's north-south and east-west main line tracks.

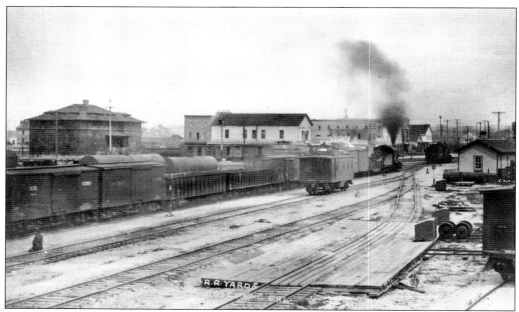

Another view includes Roseville's switching yard with the three-story Southern Pacific clubhouse building on the far left. The clubhouse was built for Southern Pacific workers and train crews. The clubhouse was formally opened on June 6, 1908.

In this close-up, the Southern Pacific Railroad clubhouse building is seen at its location on the corner of Washington and Pacific Streets. This structure was torn down around the time the Washington Street underpass was constructed in the 1950s.

Construction of the St. Rose of Lima Catholic Church in Roseville is shown in this photograph. An empty lot located on Grant Street between Oak and Vernon Streets was donated in 1908 for the site of the church.

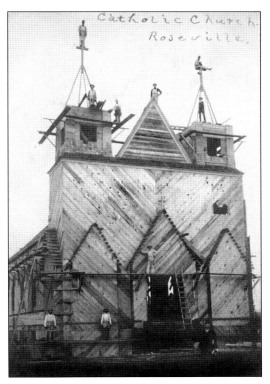

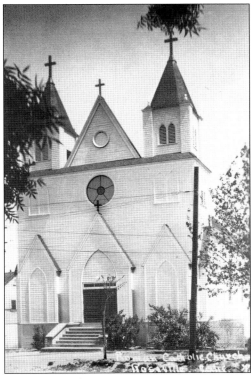

The St. Rose Church is seen here after completion of construction. This church building was replaced by the new St. Rose Church building, which was completed in the early 1960s at 615 Vine Avenue.

The main part of Roseville's First Methodist Episcopal Church, seen at left, was dedicated in March 1883. The cost was $2,500. This church still stands at the corner of Church and Washington Streets. The addition on the right was built subsequent to the original construction, completed in 1883.

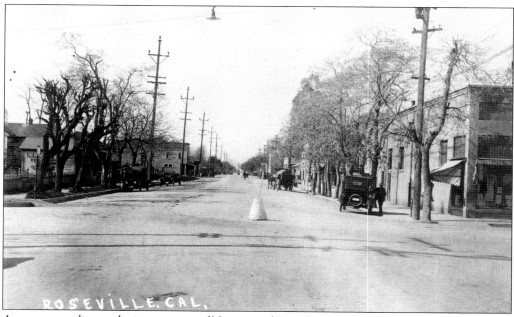

A person standing at the intersection of Vernon and Lincoln Streets would have this view looking southwest on Vernon Street. Vernon Street was the route that the transcontinental Lincoln Highway took as it passed through Roseville. In those days, the major roads usually passed right through the center of towns. As the roads were widened and straightened in later decades, they were often shifted away from the town's centers, and many communities saw business activity dry up.

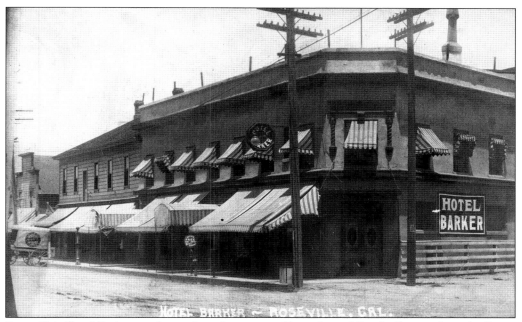

Roseville's Hotel Barker was located on the corner of Lincoln and Pacific Streets. Lincoln Street is on the left, and Pacific Street is to the right. This building still stands, but it no longer houses the Hotel Barker.

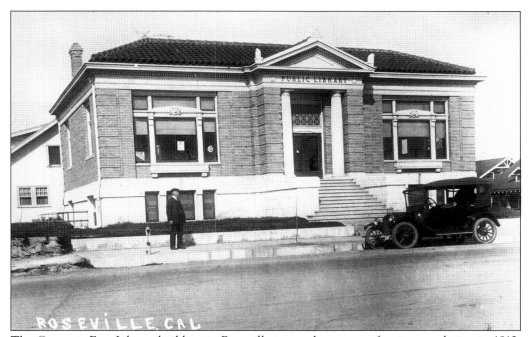

The Carnegie Free Library building in Roseville is seen here soon after its completion in 1912. This building at 557 Lincoln Street has housed the Roseville Historical Society Museum since 1979. The Roseville Genealogical Society also holds its meetings in this building.

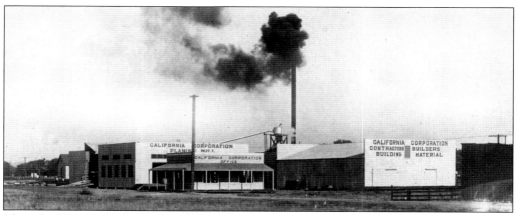

These buildings were located at the corner of Yosemite and Tahoe Streets in Roseville. The California Corporation was very active in building new homes for the people moving to Roseville after the railroad switching yard was relocated from Rocklin to Roseville in 1908.

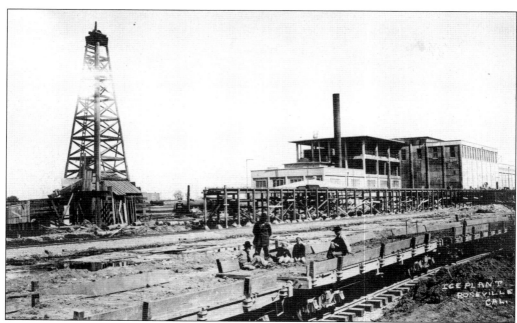

The Pacific Fruit Express (PFE) ice plant was built in Roseville in 1909, a year after the railroad switching yard was relocated from Rocklin to Roseville. Fruit and produce boxcars were iced down here in Roseville at what was the largest ice manufacturing plant in the world. Large blocks of ice were loaded into compartments built at both ends of each boxcar.

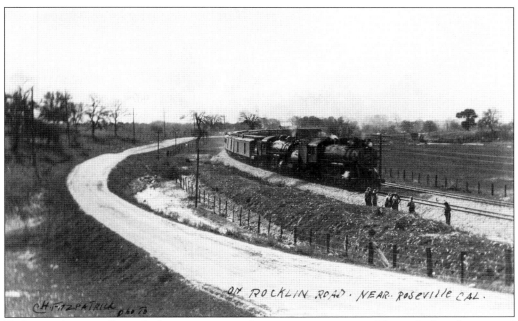

Early travelers usually took the easiest routes between communities. The early foot, horse, and wagon paths evolved into the roads between towns. Later the rail lines often also took the same route, as it was the "best" path to take. For example, the early Dutch Flat Wagon Road's route over Donner Summit was the general corridor taken by the Central Pacific Railroad in the 1860s and later was the same path in many places taken by the Lincoln Highway in 1914.

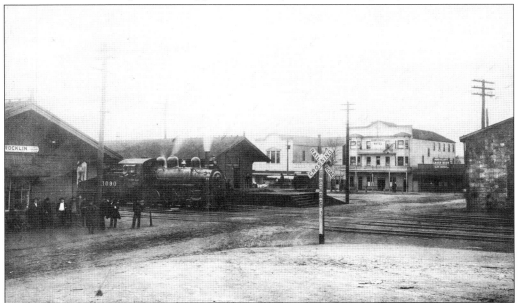

Rocklin was the original location for the switching yard for the Southern Pacific Railroad. The Rocklin train depot is at left. After the railroad's switching yard was relocated to Roseville in 1908, Rocklin suffered from minimal population growth for many decades until the 1960s, when homes were built in the Sunset Whitney development adjacent to Rocklin.

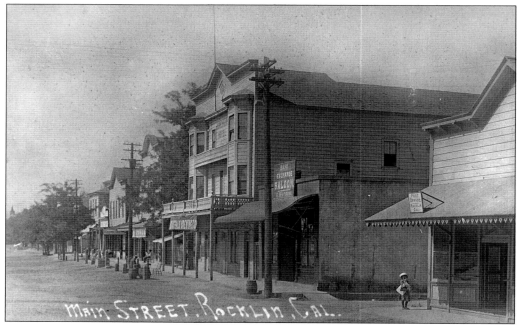

The large three-story building (the Burchard Hotel) in the center of this image is the same building seen across the tracks from the Rocklin depot in the image at the bottom of the previous page. The building at the extreme right of this image has a small sign on the awning indicating it was the location of Rocklin's post office at the time this photograph was taken.

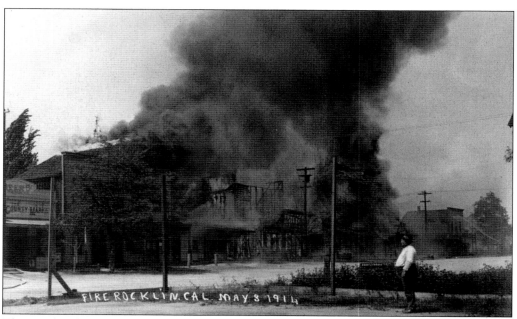

The Burchard Hotel was one of the many Rocklin buildings consumed by the fire of 1914. The fire raced among the buildings located on Rocklin's Front Street. Front Street was one of the two main streets in Rocklin, the other being Railroad Street.

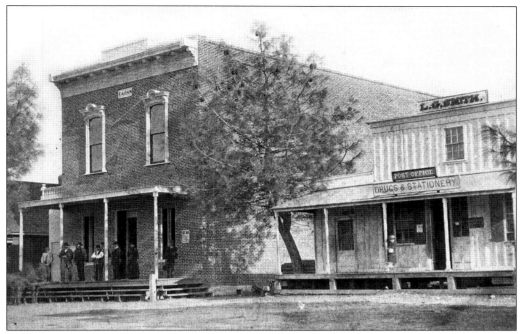

L. G. Smith's drug and stationery store is seen on the right. When this photograph was taken, the Rocklin Post Office was in Smith's store. The job of postmaster was often an additional job for local businessmen, and the post office migrated to the postmaster's place of business. The two-story brick building at left is the Levison Brothers store.

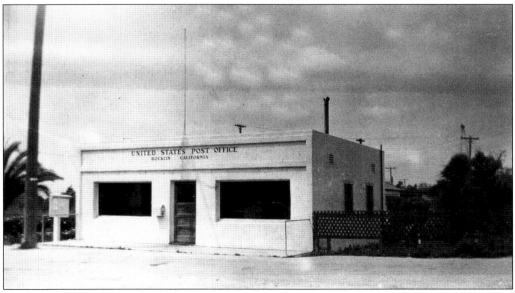

The Rocklin Post Office building is pictured as it was in the 1930s. There was a trend around this time to moving post offices into a dedicated building.

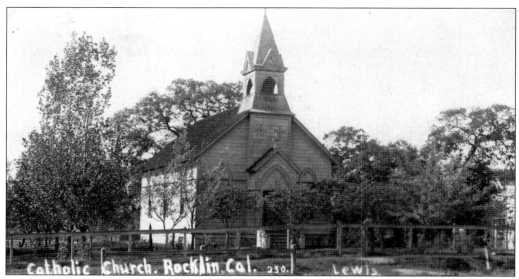

A lady named Rosa mailed this postcard with a view of Rocklin's St. Mary's Catholic Church to a female friend in Groton, Massachusetts. The note on the back of the postcard says that Rosa was in town to visit the Placer County Fair of 1907.

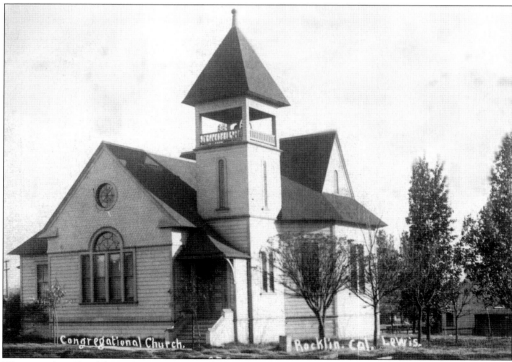

This is what Rocklin's Congregational church looked like around the same time as the 1907 postcard image above showing the Catholic church.

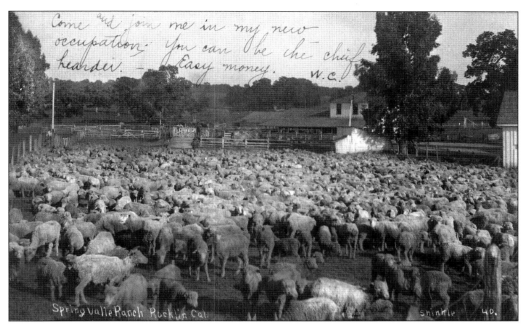

The Spring Valley Ranch on the Whitney property outside Rocklin was the site of a large sheep ranch. A photographer named John Shinkle, who was from the town of Woodland in Yolo County, took the two pictures on this page.

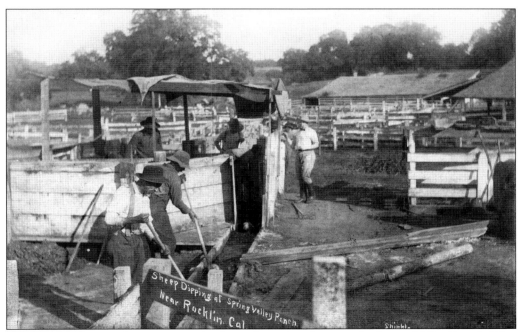

Ranch hands are seen here running the sheep through a chute on the Spring Valley Ranch. This process forced each sheep deep into an insecticide bath meant to kill any vermin living in the sheep's wool or on their skin.

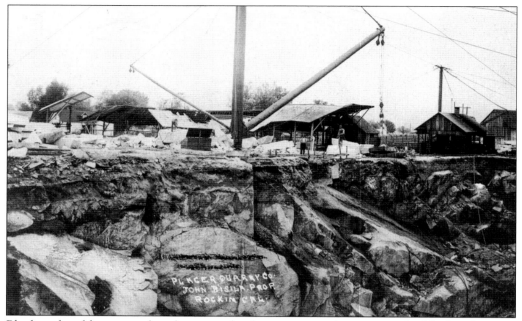

Block and tackle mounted on large wooden beams was used to remove the blocks of granite from this quarry in Rocklin. The photographer who took this photograph scratched identifying information for this image on the bottom of the negative.

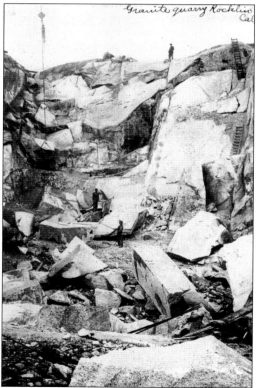

Tons of granite were quarried at the many sites around the communities of Rocklin, Loomis, and Penryn. This photograph shows the scale of operations at one of the Rocklin quarries.

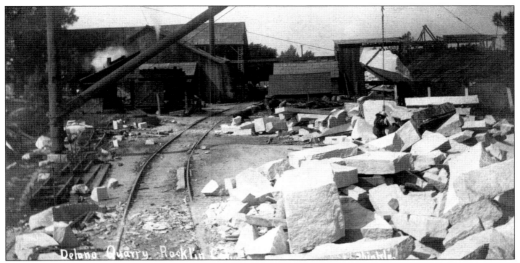

The photographer identified this image as being the Delano Quarry in Rocklin. Like the sheep ranch pictures seen on page 27, this quarry image was taken by John Shinkle of Woodland.

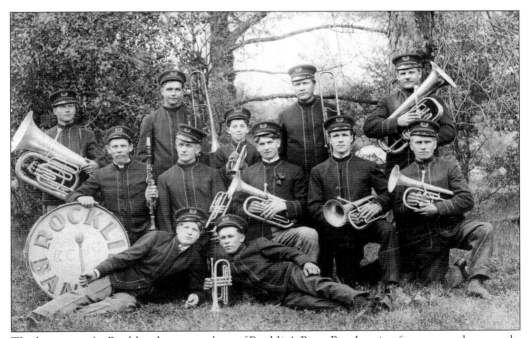

The last image for Rocklin shows members of Rocklin's Brass Band posing for a group photograph. Bands were important sources of entertainment and pride in even the smallest of towns. Bands would put on concerts, participate in parades, and perform at many social functions. (Courtesy of Dana Scanlon.)

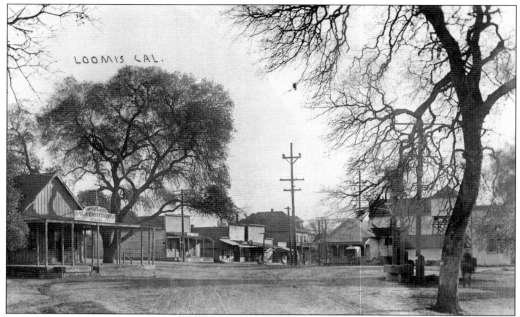

The Loomis Beer Garden is the first building on the left. A sign says Sacramento and Eastern beers can be obtained on the premises. The small building in the center of the image just to the right of the telephone pole is the Loomis Meat Market.

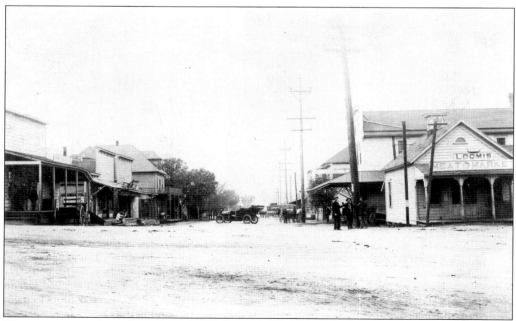

This image provides a close-up view of the Loomis Meat Market building at right. Two men can be seen reading the day's newspaper while they are sitting on the front steps of the Loomis Drug Store at left.

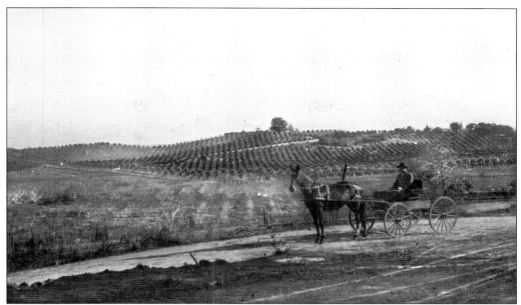

At first glance, this nondescript photograph of a barren hillside with a newly planted orchard and a man in a horse and buggy is almost meaningless. Old photographs were often not identified. This image could be of many different geographic locations in many different states across America. Luckily, this image was on a postcard that was mailed in 1911. Read the caption at the bottom of this page to find out where this scene is located.

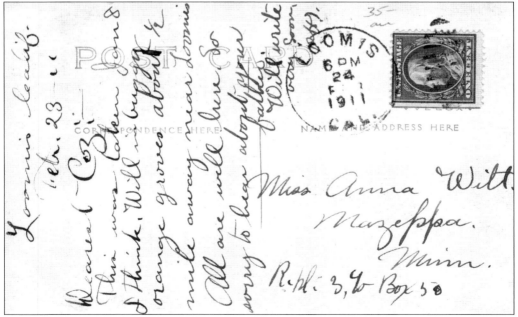

A great feature of postcards is that they were often mailed, and there were messages on the postcards. The back of the postcard shown at the top of this page shows that the card was mailed from Loomis in 1911. The man in the buggy is identified as Will, and the orchard is one comprised of newly planted orange trees.

The All Saints Episcopal Church in Loomis is pictured around 1907.

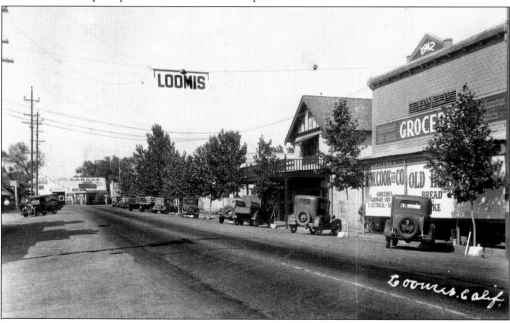

Loomis's main street is here as it looked in the early 1930s. Cook and Company's grocery and hardware store is on the right. Frank W. Cook's grocery store building was erected in 1912, as indicated by the sign at the very top of the storefront. This street was the path the Lincoln Highway took, and later it was the route of U.S. Highway 40. It is now known as Taylor Road.

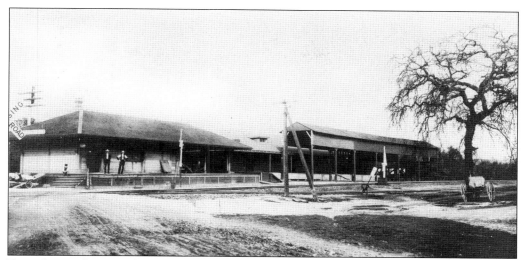

Even the small town of Penryn, just east of Loomis, had its own depot. As mentioned in the caption for the Sheridan depot on the bottom of page 12, railroads moved people and goods around the nation, and even the smallest towns usually had their own depot in the late 19th and early 20th centuries.

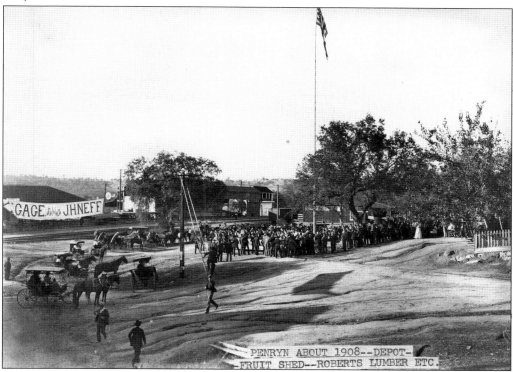

A crowd is gathering at the Penryn depot in this photograph. A note pasted on the image says it was taken about 1908. Actually, the large banner with the names Gage and J. H. Neff refers to a campaign of 1898 when Henry T. Gage was running for governor and Jacob Hart Neff was running for lieutenant governor of California on the Republican ticket. (Courtesy of Placer County Museums Division.)

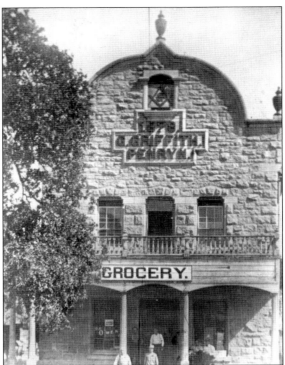

Griffith Griffith, a Welsh immigrant, owned a granite quarry in the Penryn area. During the economic slump of 1878, Griffith kept his quarrymen employed by having them construct this building using granite from his quarry. The bottom floor was occupied by grocer Owen Owen.

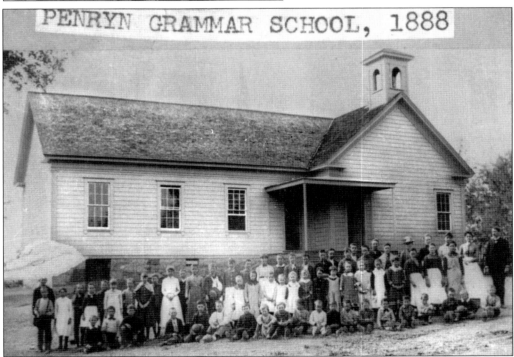

The children of the Penryn area families employed in the quarry and in the local orchards are seen here posing for a school photograph. (Courtesy of Placer County Museums Division.)

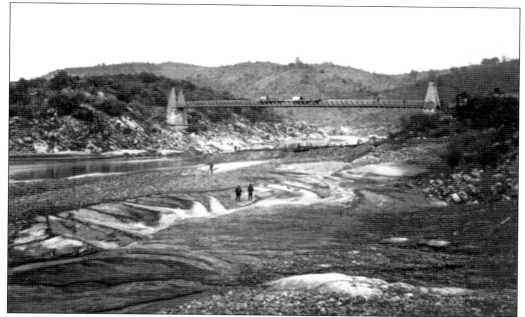

During the earliest years of the California Gold Rush, men panned the gravel along the rivers flowing down out of the western slopes of the Sierra Nevada range. Rattlesnake was a town founded right on the bank of the North Fork of the American River. A bridge was built across the river from the Placer County side over to El Dorado County. (Courtesy of Society of California Pioneers.)

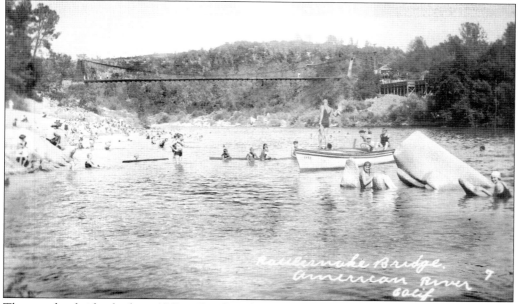

The wooden bridge built in 1862 at Rattlesnake was replaced with this wire-cable bridge. The Rattlesnake Bar area was a popular place to swim for locals from the Rocklin, Loomis, Auburn, and Penryn communities. The wire bridge collapsed in December 1954 under the weight of a crossing truck. The bridge was not replaced, as it would have soon been covered by the waters of Folsom Lake, which was created by Folsom Dam, completed in 1956.

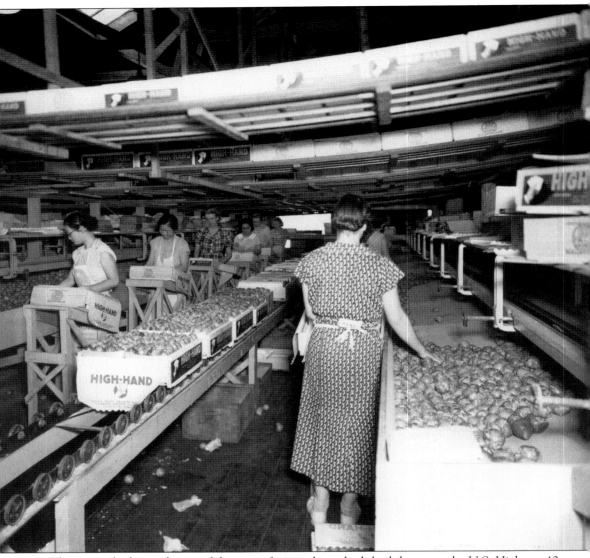

This image looks inside one of the many fruit packing sheds built between the U.S. Highway 40 roadbed and the railroad tracks in the small towns of Placer County. The High Hand crate labels seen on the boxes packed with fruit identify this packing shed as being located in the town of Loomis. The Japanese ladies in this image place it most likely before World War II, as Japanese citizens across the United States were sent to internment camps soon after the Japanese attack on Pearl Harbor on December 7, 1941. This row of packing sheds still stands in Loomis at the intersection of Taylor Road and Oak Street. The sheds are hard to miss today as High Hand signage is used extensively on the outside walls of the building.

Two

FOOTHILLS OF
PLACER COUNTY

This chapter contains images of communities and points of interest in the foothills of Placer County. For the purposes of this book, the 1,000-foot-elevation mark begins the foothills of the Sierra Nevada chain, which runs north and south, roughly forming the border between California and Nevada. The foothills constitute the lower elevations above the valley floor and below 3,000 feet, at which elevation the winter snows sometimes get deep enough to close the roads to traffic. The foothills are where gold was discovered in 1848 and where the earliest forty-niners panned for gold. Later the foothills became a center for the fruit industry in California. As in chapter one, the images of communities and points of interest will be grouped in a west-to-east order, essentially following the path of Interstate 80 and the Union Pacific Railroad's (the Central Pacific Railroad became Southern Pacific and Southern Pacific became Union Pacific) main line route from San Francisco to Ogden, Utah, as they both pass through the heart of Placer County heading up to Donner Summit. The foothills section of Placer County that is located in the southeastern part of the county will be covered in the fourth and last chapter in this book, Forest Hill Divide.

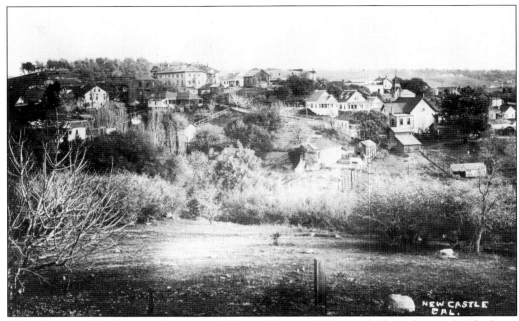

This photograph looks into the center of the small town of Newcastle from the south. The large building at the top of the hill just left of center in this image is the rear of the Pomona Hotel.

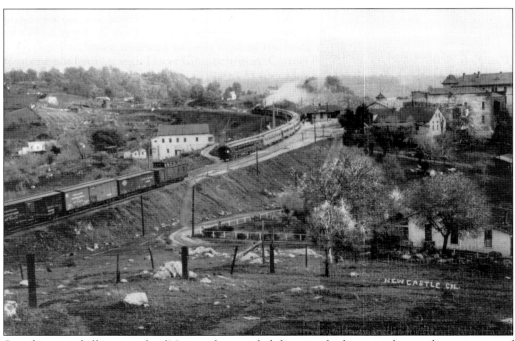

Standing on a hill just south of Newcastle provided this view looking north into the main part of town. The Pomona Hotel is on the far right. The Newcastle fruit sheds are in the middle of the image, just to the right of a Southern Pacific train as it makes the gentle turn left.

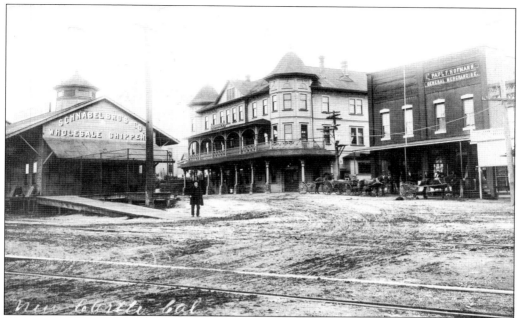

The Pomona Hotel, with its round turrets, was the main hotel in town. Though Newcastle never had a large population, its importance as a major fruit shipping center warranted a large, impressive-looking hotel built near the depot and the fruit sheds.

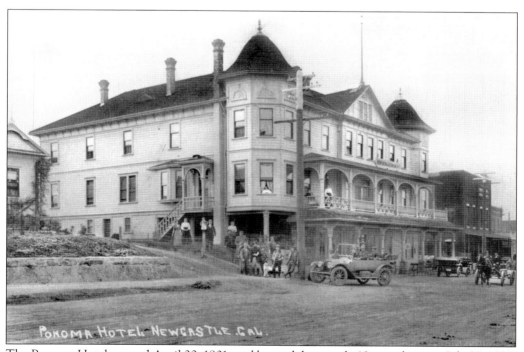

The Pomona Hotel opened April 20, 1901, and burned down only 19 years later on July 28, 1920. The gutted shell of the Pomona stood for a few years before it was finally all torn down. (Courtesy of Jim Johnson Photography.)

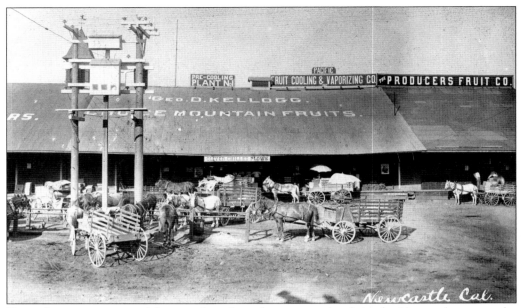

Horse-drawn wagons are delivering fruit from the many orchards in the Newcastle area to the fruit sheds built along the railroad tracks. In 1894, some 20 million pounds of fruit were shipped from Newcastle. These sheds were built at the site after a fire in January 1900.

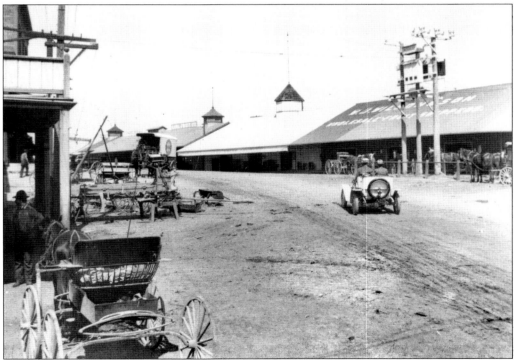

An early "horseless carriage" can be seen motoring up the street among the horses and buggies parked near the Newcastle fruit sheds. The Newcastle fire of 1922 destroyed a large percentage of these fruit sheds, which had been built after the earlier fire of 1900.

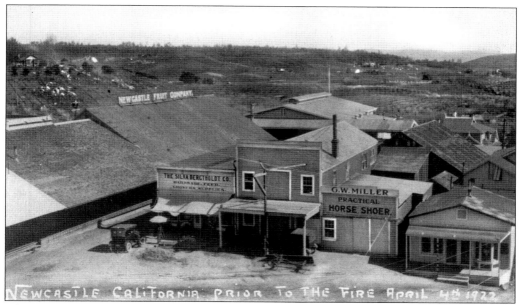

This is a rare bird's-eye view of the group of business buildings located adjacent to the fruit sheds in Newcastle. This photograph was taken before the fire of 1922. (Courtesy of Jim Johnson Photography.)

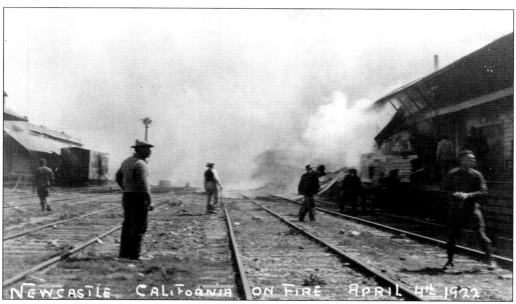

Newcastle suffered from another serious fire in the spring of 1922. Fires were not the only problem though; a pear blight struck orchards throughout Placer County in the 1960s. Pear acreage declined from 5,400 acres in 1960 to only 1,500 acres by 1966. The blight and a drop in pear prices crippled the fruit business in much of Placer County.

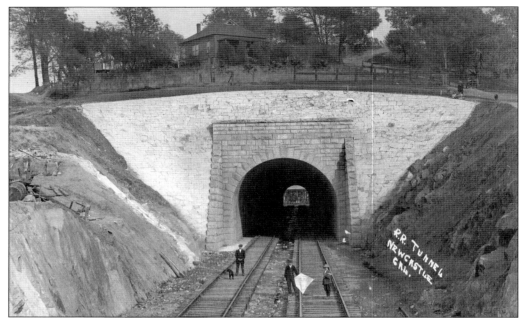

A boy and his dog, with some kite-flying friends, pose in front of the train tunnel cutting through a small hill in Newcastle. The double tracking of the Southern Pacific Railroad reached Newcastle by 1910. This tunnel fit both the east and west bound tracks, which would separate by miles in some places to merge back together and even cross each other heading east up to Donner Summit.

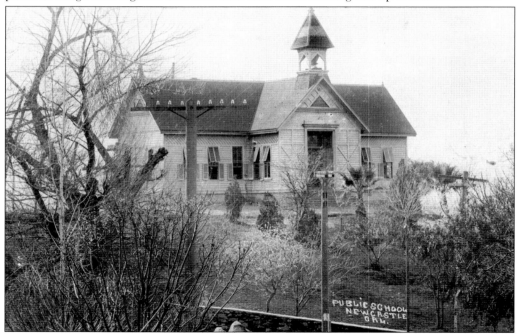

The moderate size of the local grammar school building in Newcastle provides some indication of the population for the Newcastle area around the dawn of the 20th century. As one heads east after leaving Newcastle, the next community before reaching Auburn is Ophir.

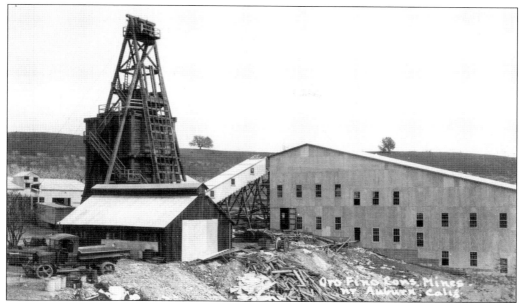

The mines around Ophir provided employment for those not involved in the fruit business. Oro Fino was one of the largest of Ophir's mining properties. Gold was not deemed a strategic metal during World War II, and many gold mining operations across the country shut down during the war. The Oro Fino Mine was no exception and ceased operation in the early 1940s.

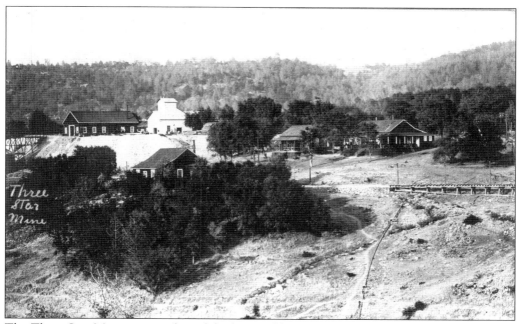

The Three Star Mine was another of the large gold mining operations thriving in Ophir prior to World War II. The Three Star Mine was located on Wise Road, south of Krag Lane over the ridge to the west of the Oro Fino Mine.

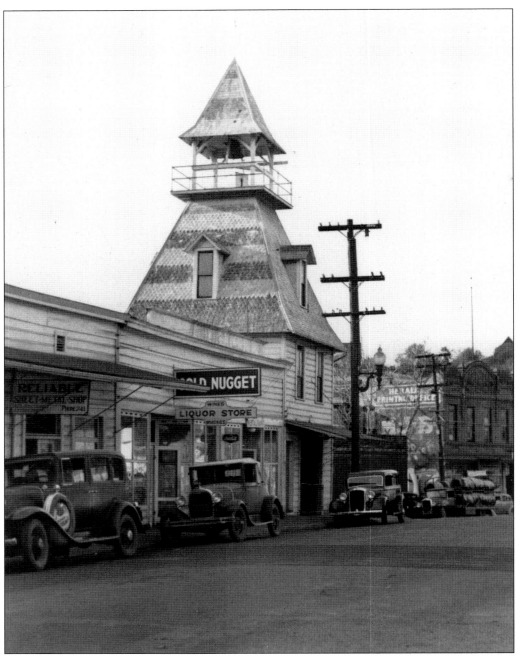

Firehouse No. 2 still stands in Auburn's old part of town, but it was moved from its original location (seen here) to a new spot about 25 yards east to get it out of the way of the Interstate 80 off-ramp. The large brick building just beyond the firehouse in this photograph was the location of the *Placer Herald* printing office for many decades. The *Placer Herald*'s printing press can be seen at the top of page 46. Auburn's first firehouse (Firehouse No. 1) was built near the Auburn depot at the top of Rail Road Street. Firehouse No. 1 was also relocated from its original site to a new spot near the Highway 49 under-crossing of the railroad tracks.

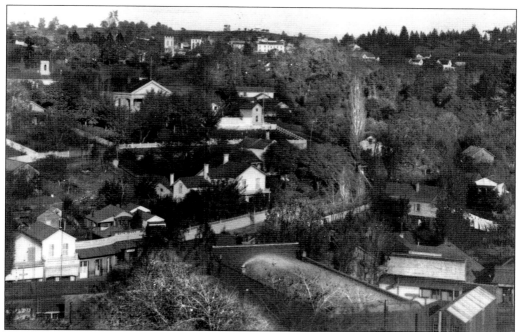

An early 1880s photograph of Auburn shows much of the oldest part of town. The rounded front of the Union Saloon can be seen in the lower left-hand corner. This building with its distinctive rounded front is occupied today by a restaurant. Just above the Union Saloon building can be seen the old Placer County Courthouse building with its round columns.

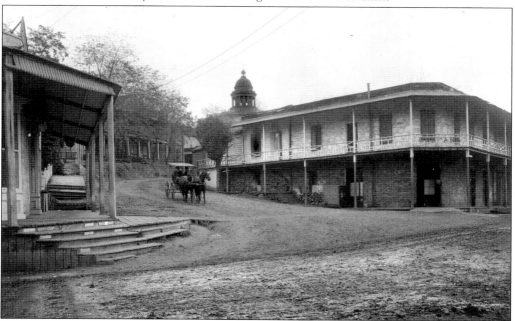

The cupola of the new Placer County Courthouse (dedicated in 1898) can be seen just peeking out above the New Orleans Hotel in Old Town Auburn. The hotel was torn down in 1959. There is a Valero gas station on the hotel's property now.

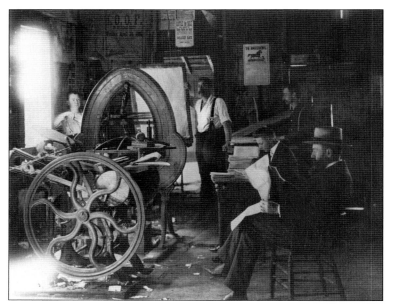

Men pose around the printing press in the *Placer Herald* building located in Auburn. The press machine printed the *Placer Herald* newspaper. The *Placer Herald* has long claimed to be the oldest continuously printed paper in California. The date of its first printing was September 11, 1852. (Courtesy of Jim Johnson Photography.)

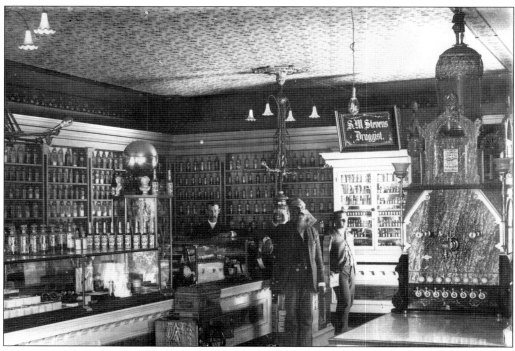

Here is an interior view of Solon Mills Stevens's drugstore located at the corner of Main and Commercial Streets. The large sign in the store abbreviates his name as S. M. Stevens.

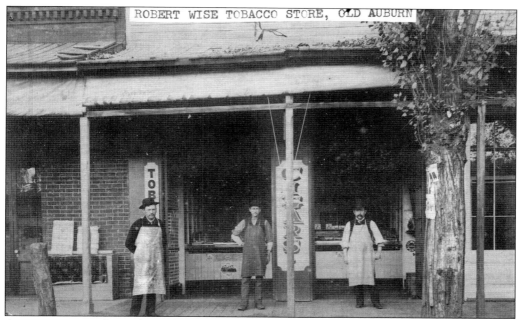

An exterior view shows the Robert Wise cigar manufacturing and sales building located in Old Town Auburn. Cigars and pipes were the primary means for smoking tobacco in the late 19th and early 20th centuries. Cigarettes became more popular starting in the 1920s. (Courtesy of Placer County Museums Division.)

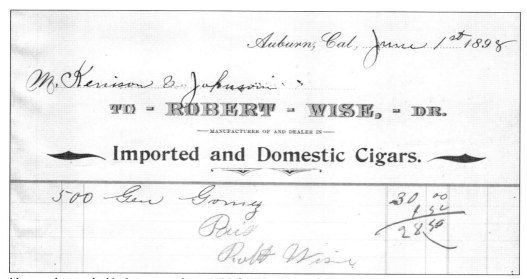

Here is the top half of a receipt from 1898 for 500 General Gomez cigars sold by Robert Wise to Kenison and Johnson, who were partners in a retail store in Auburn. General Gomez was Robert Wise's own brand of cigars, made in his manufacturing facility, shown at the top of this page.

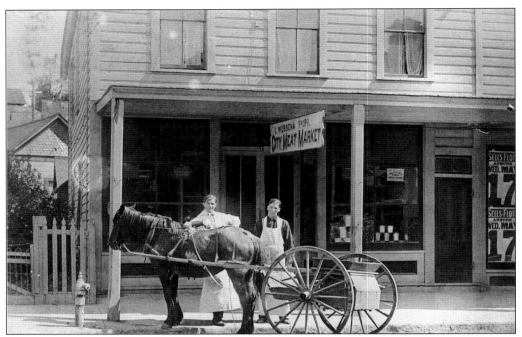

Lester Davidson was an employee at the Wubena City Meat Market located on Rail Road Street in Auburn. Lester, on the left, is posing out front with the market's horse-drawn delivery cart. The signs in the window at far right are advertising the Sells Floto Circus, scheduled for an appearance in Auburn on Wednesday, May 17, 1911.

This unusual view of Lincoln Way, taken in 1931 from the roof of Auburn's Masonic temple, shows the State Theater at left. Its marquee is advertising the 1930 film *Midnight Special*. The Traveler's Hotel at top right stood at the corner of Lincoln Way and Pine Street. The hotel building was torn down more than a quarter century ago. (Courtesy of Kathleen Warwick-Duncan.)

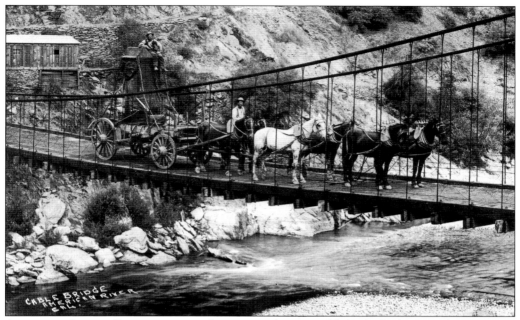

A wagon and team of horses are stopped to pose on the wire-cable bridge built across the American River just below Auburn. The road crossing this bridge led to Cool and Placerville in El Dorado County. This image is a photograph on a postcard, and there is an interesting message on the back (see below).

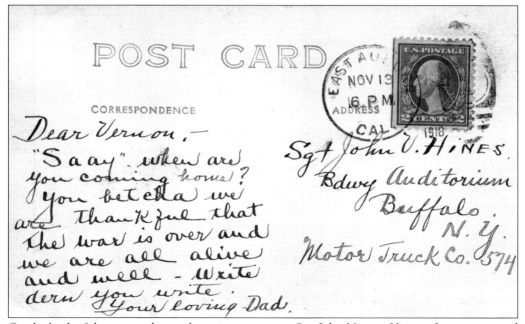

On the back of the postcard seen above is a message to Sgt. John Vernon Hines, who was assigned to the Motor Truck Company 574 stationed at the Broadway Auditorium in Buffalo, New York. The auditorium was the location of a New York state armory and thus a logical place to station troops returning from fighting overseas in World War I.

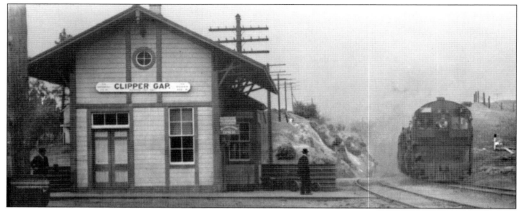

Clipper Gap has always been a small community just a few miles east of Auburn. Though Clipper Gap had a very small population, like other small communities of the time, the town's substantial depot belied its stature as a small town. (Courtesy of Jim Johnson Photography.)

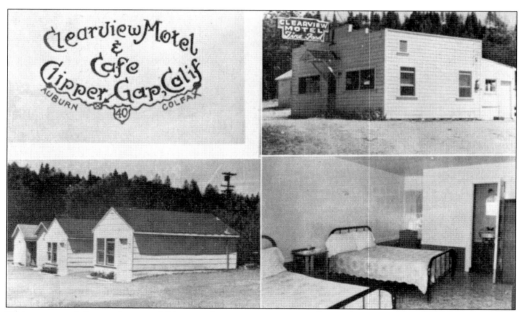

This postcard shows that roadside motels were very spartan for early motorists. The sign above the entrance to this very modest rest stop nevertheless still advertises "Fine Food." These early roadside motels were a sign that the United States' highways were starting to supplant the railroads.

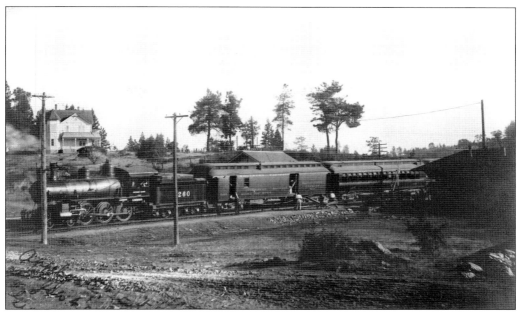

Like Clipper Gap, Applegate was a small community with a nice train depot for the pickup and delivery of passengers and freight. The depot's Applegate sign can just be made out on top of the station building's roof on the far right. Applegate had some well-known resorts during the first half of the 20th century, and most people planning to recreate at those resorts reached Applegate by train.

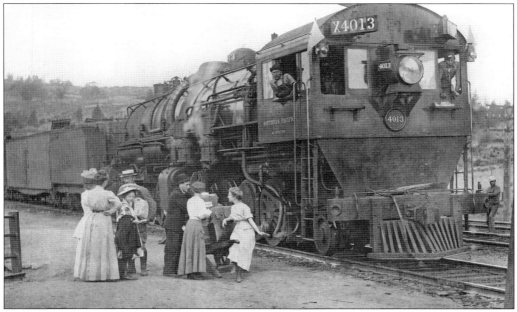

Passengers are waiting to board the train at Applegate. This is the image used on the front cover of this book. Everyone in this picture seems to be posing for the photographer. Engine X4013 was one of the cab forward engines designed to put engineers in front of the engine's smokestacks, which worked well when going through the 30 miles of snow sheds built up over Donner Summit.

The building at left is George Hepburn's general store and post office in Applegate. George Hepburn was one of the early settlers of the Applegate area. He bought the general merchandise store in Applegate in 1892 and kept expanding it until 1899, when he moved the store to the location nearer the main road as seen in this 1910 image.

Here is a close-up view of the Hepburn store at Applegate. Though only a small business owner in a small town, George Hepburn was well known throughout most of Placer County. George Hepburn was the postmaster in Applegate for 30 years.

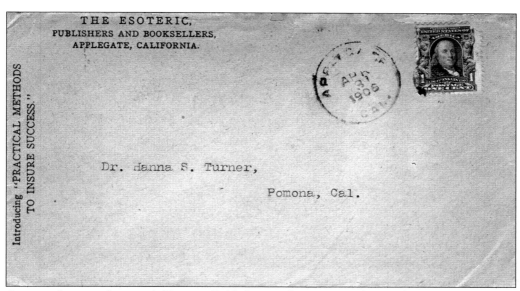

A scan of an envelope with Esoteric Publishing information is shown above. Hiram Erastus Butler started Esoteric Publishing in Boston where he published his book *Solar Biology* in 1887. He relocated to Applegate in 1891. The property in Applegate was used as a religious retreat for those that H. E. Butler considered like-minded thinkers. A book published out of Applegate was *The Goal of Life or Science and Revelation*.

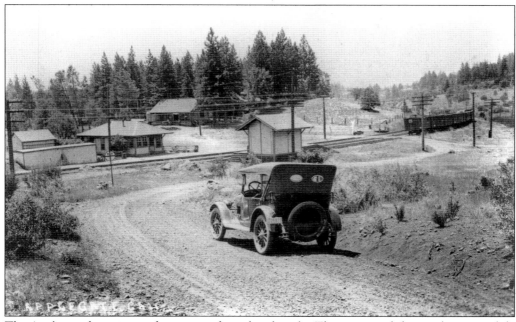

The Applegate depot is seen from across the railroad tracks. There is a good chance the automobile in this image was owned by the photographer. (Courtesy of Jim Johnson Photography.)

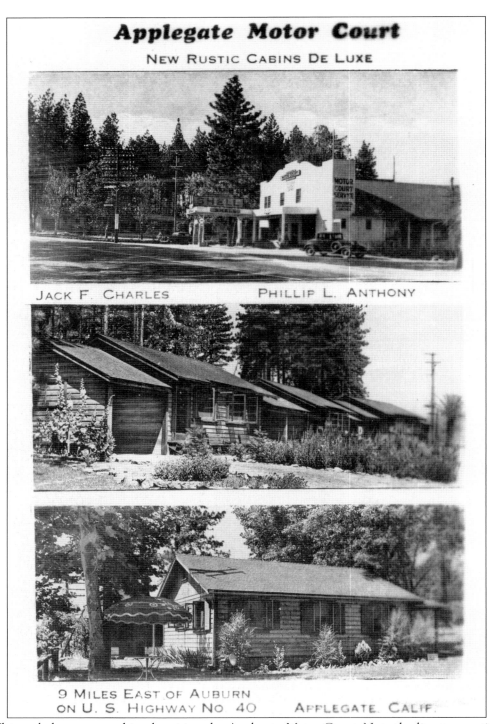

Applegate Motor Court

NEW RUSTIC CABINS DE LUXE

JACK F. CHARLES PHILLIP L. ANTHONY

9 MILES EAST OF AUBURN
ON U. S. HIGHWAY NO 40 APPLEGATE, CALIF.

This real-photo postcard is advertising the Applegate Motor Court. Note the line trumpeting the availability of "rustic" yet "De Luxe" sleeping cabins. Even 70 years ago, people were trying to appeal to Americans' desire for a rustic experience in a comfortable environment.

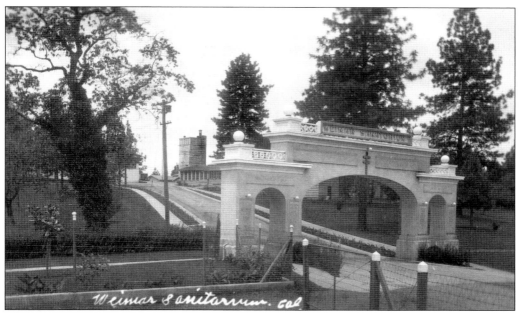

The front entrance to the Weimar Sanitarium was right on old U.S. Highway 40. The Weimar Joint Sanitarium opened on November 17, 1919. These entrance arches still stand. After tuberculosis cases lessened in later years, the sanitarium converted to a general hospital.

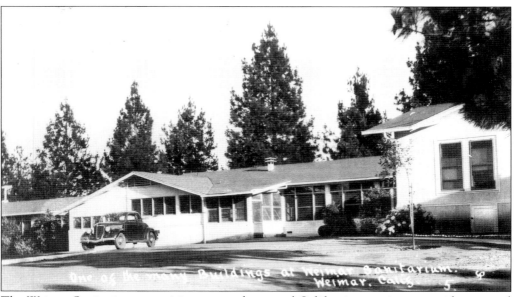

The Weimar Sanitarium was a joint venture by several California counties to provide a central place for treatment of tuberculosis. Dr. Robert Alway Peers of Colfax served as advisor to the sanitarium's multicounty governing board. Dr. Robert Peers was nationally recognized as a specialist in the field of tuberculosis and was the first Colfax resident to be included in *Who's Who* while still living in Colfax.

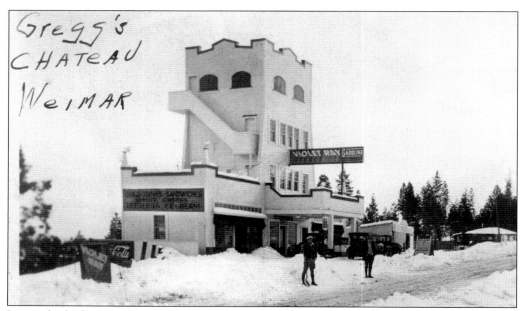

Located a little more than a mile east from the entrance to the Weimar Sanitarium was this unusually tall roadside gas station and restaurant, initially known as Gregg's Chateau.

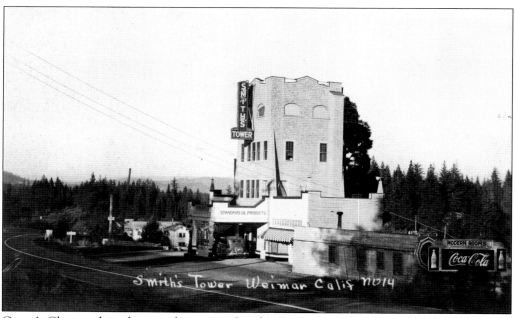

Gregg's Chateau later became known as Smith's Tower. Another famous U.S. Highway 40 restaurant called the Budapest can be seen just beyond Smith's Tower at the curve in the U.S. Highway 40 roadbed.

Lou LaBonte originally lived in Los Angeles and earned his living as a Hollywood music arranger. He moved his family to the foothills and opened his first restaurant in the Smith's Tower building in 1946. The top floor was known as the Skyroom and was reserved for private parties. Lou LaBonte's relocated from Weimar to Auburn in 1955. This four-story structure no longer exists.

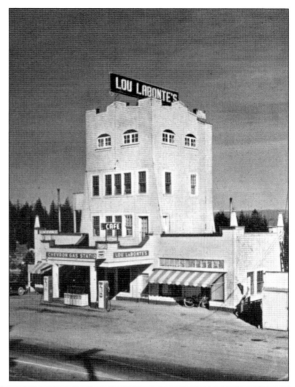

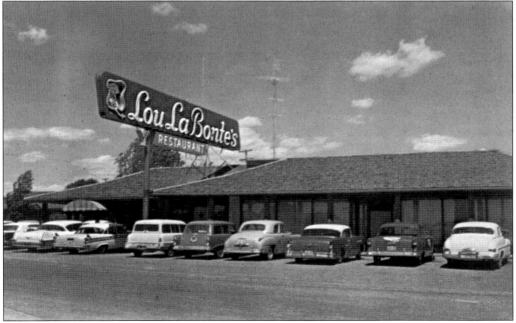

Lou LaBonte's restaurant is seen here at its current location in Auburn. Lou LaBonte's opened in Auburn after relocating from Weimar and is still open for business today after more than 60 years at this location in Auburn adjacent to Interstate 80.

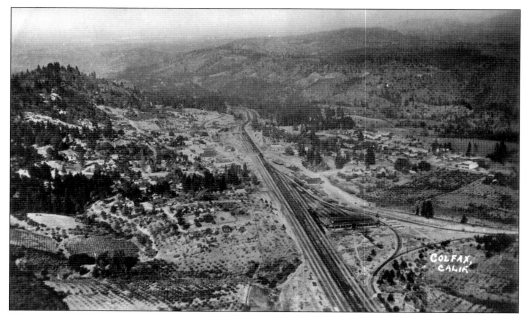

This aerial view of Colfax is looking down on the town from the southwest. The railroad tracks cut through the center of the town heading northeast toward the Long Ravine trestle and then onto Cape Horn. The Southern Pacific Railroad roundhouse building can be seen amid all the curving sections of tracks, known as the wye.

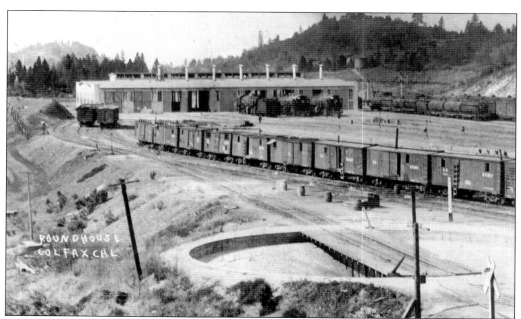

Colfax had its own roundhouse about a mile southwest down the tracks from the depot building. The roundhouse existed at this location from 1912 to 1930. Many roundhouses were not actually round.

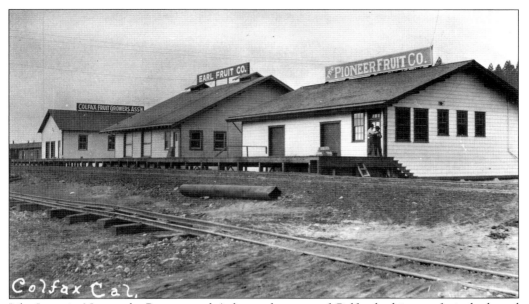

Like Loomis, Newcastle, Penryn, and Auburn, the town of Colfax had it own fruit sheds and offices. These three buildings were located down the tracks a couple of hundred yards from the Colfax depot. The building at end of these three was headquarters for the Colfax Fruit Growers Association, formed in 1917.

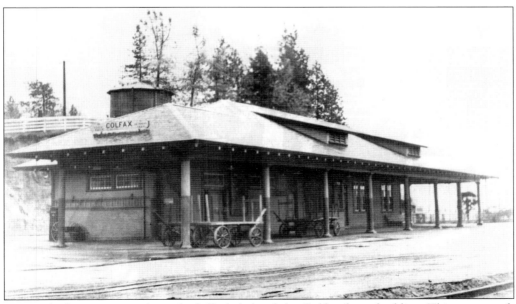

Notice the large water tank on the hillside behind the Colfax depot building. This water tank is seen in a photograph on page 64 and will help provide some orientation for the reader when viewing the image on that page. The depot building is currently being used by the Colfax Area Historical Society as a museum.

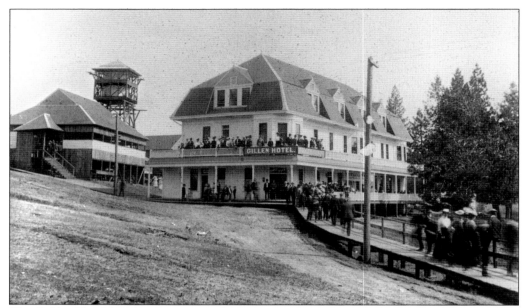

The Colfax Hotel building was originally known as the Gillen Hotel after Daniel Gillen, who built the large structure. The grand opening of the Gillen Hotel occurred March 13, 1903, the same year Pres. Theodore Roosevelt's train stopped in Colfax. The building to the left of the Gillen Hotel was a dance pavilion featuring a dance floor supported by large springs.

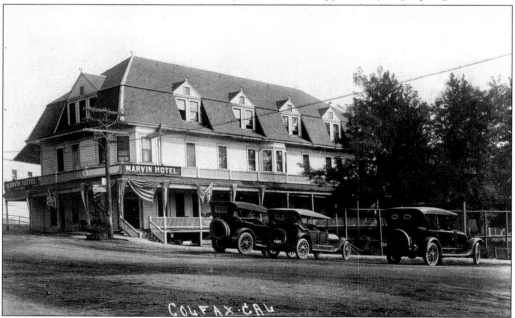

The Gillen Hotel was leased to Fred Marvin, who renamed it the Marvin Hotel. Marvin now owned the two hotels just across from each other, and both were named for him. In 1923, the Marvin Hotel (the original Gillen Hotel) was renamed the Colfax Hotel. That name lasted throughout the rest of the 20th century, and it is still the name used for the building as of the printing of this book.

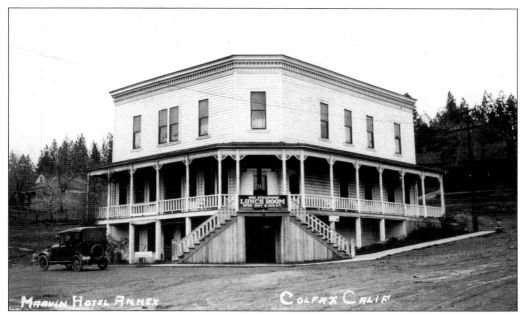

Only a couple of years after the Gillen Hotel was built, in 1905, Fred Marvin constructed a hotel just across the street and named it after himself. A close-up of the Marvin Hotel shows a large sign advertising a lunchroom used not only by guests staying at the Marvin, but also for the passengers of the trains stopping in Colfax. This Marvin Hotel building burned down in 1939.

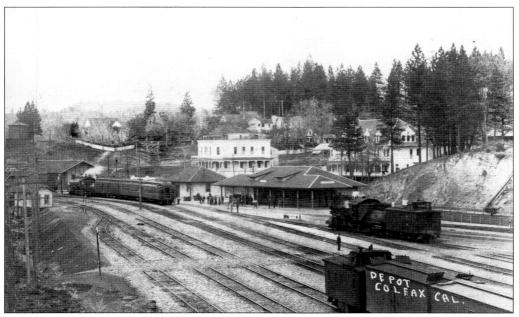

The many tracks seen here are coming up from the roundhouse. The Colfax depot is on the right. Just over the top of the depot building can be seen the two-story white building known as the original Marvin Hotel. Behind the depot and to the right of the Marvin Hotel is the Gillin/Marvin/Colfax Hotel building almost obscured by trees.

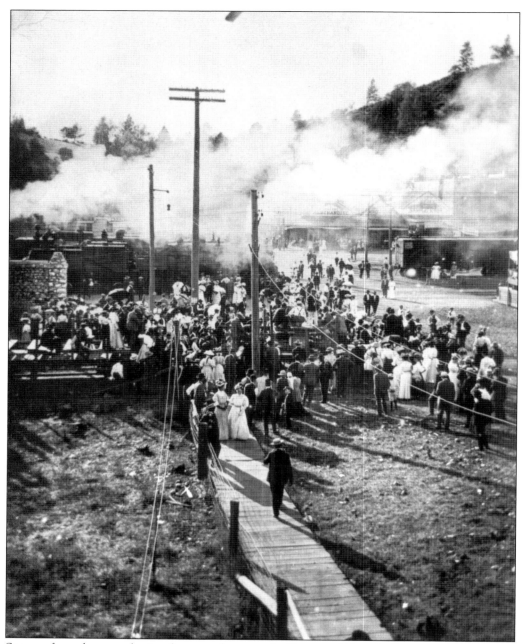

Scores of people are gathering from nearby towns in Placer and Nevada Counties to witness the 1907 dedication of the Nevada County Quartz Monument, seen at the left-hand margin of this image. Nevada County donated the money to have the monument built in the Placer County town of Colfax. The wooden boardwalk leads up to the Gillen Hotel. This image often appears in other books, and the caption often used in those books claims it is of people gathering to see Pres. Theodore Roosevelt's train stop in Colfax on May 19, 1903. However, the Quartz Monument can be seen at the left edge of this photograph, and since the monument was not built until 1907, this image cannot be of people gathering for President Roosevelt's train.

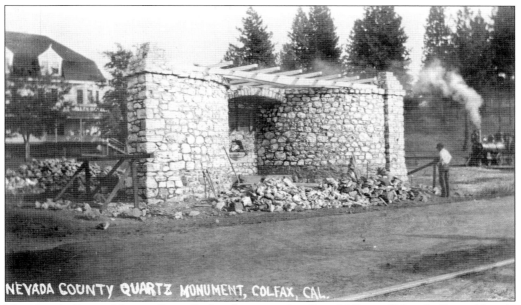

NEVADA COUNTY QUARTZ MONUMENT, COLFAX, CAL.

The Nevada County Narrow Gauge Railroad originated in Grass Valley and Nevada City in Nevada County; its other terminus was here in Colfax. To promote Nevada County, this monument of quartz was built near the Colfax depot building in 1907. The monument is shown here under construction. This monument had a short but active life as it was moved about 25 yards across Grass Valley Street in July 1914 and torn down before 1920.

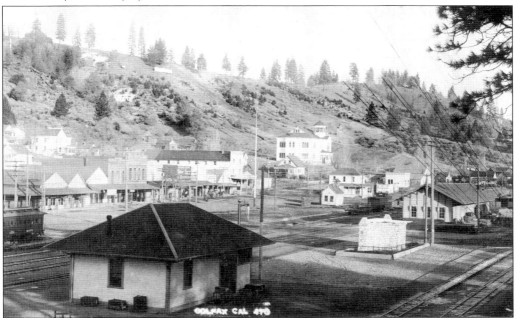

COLFAX CAL 418

The small building at the bottom left is the Wells Fargo office. The white structure to its right is the Quartz Monument, shown from the rear. The Southern Pacific's main line tracks lie to the monument's left; the Nevada County Narrow Gauge Railroad tracks lie to its right. The two-story grammar school building stands in the distance.

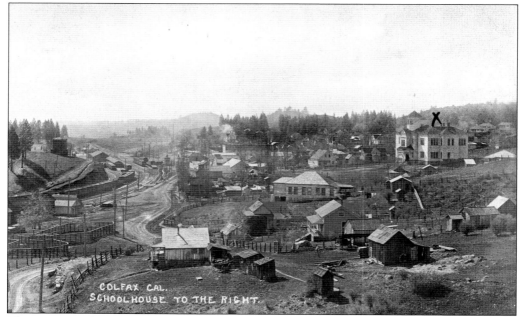

The person mailing this postcard of Colfax marked the image with an "x" over the schoolhouse building. The two-story Victorian school marked here was opened in 1894 but burned down just 18 years later in 1912. At the left side of the image, the large water tower mentioned at the bottom of page 59 can be seen situated on the hillside just above the Colfax depot.

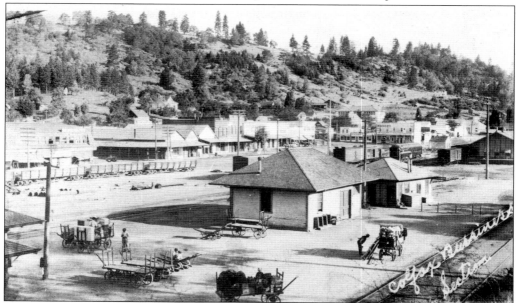

This Colfax photograph shows the back of the Wells Fargo office surrounded by baggage carts. The Quartz Monument has been torn down, and a small building was erected just beyond the Wells Fargo office where the monument originally stood. One of the reasons the Quartz Monument was torn down was that vandals were constantly removing quartz pieces from the monument hoping that the pieces contained gold.

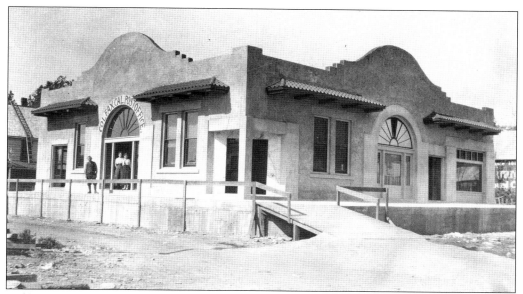

Colfax's new post office building, erected in 1917, can easily be identified by a sign that wraps around the curved archway above the door into the post office portion of the building. Two women pose in the post office doorway.

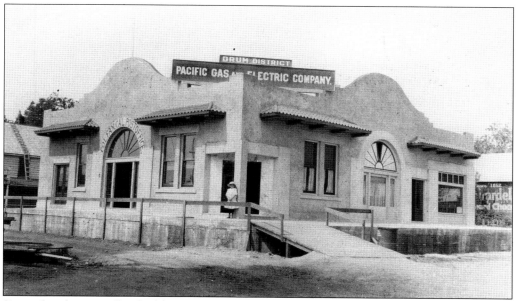

Soon after the post office building was completed in 1917, the Pacific Gas and Electric Company's Drum Division office relocated from the Lobner Building in Colfax to the post office building. The building became home to both the post office and the PG&E Company's Drum Division headquarters, as evidenced by the addition of the new sign on top of the building. Today this building at Main and Church Streets houses Colfax's library.

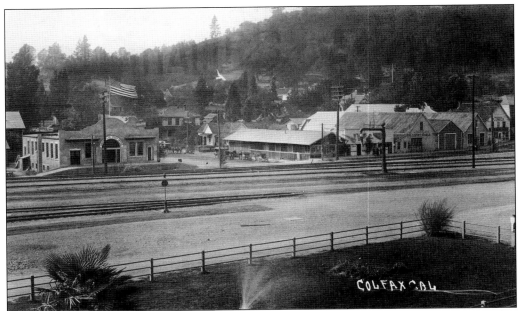

A photographer standing on the Colfax depot platform took this picture of the Colfax Post Office building, across the tracks, with a large American flag blowing in the breeze. The livery stable at right of the post office is where the Colfax City Hall is now located. Church Street runs up the hill between the post office building and the livery stable and passes in front of the Methodist church seen below.

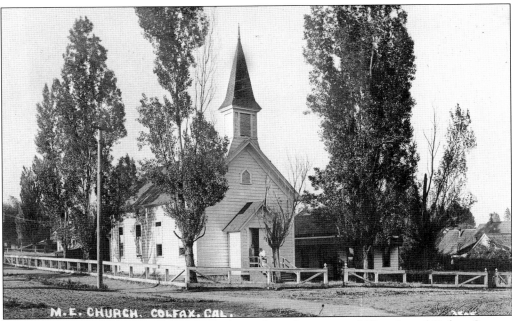

Colfax's Methodist Episcopal church was located on the corner of Church and Culver Streets. The church building seen in this photograph was built in the fall of 1874 on the spot where the first Methodist Episcopal church had stood until fire destroyed it in May 1874.

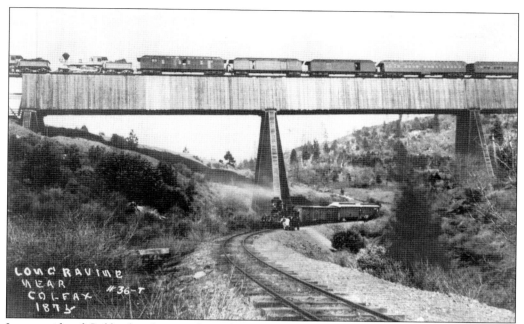

LONG RAVINE
NEAR #36-T
COLFAX
1875

Just outside of Colfax heading eastbound on Interstate 80 are two long steel railroad trestles crossing overhead. This double set of trestles is known as the Long Ravine trestle. The original wooden trestle built in the 1860s is seen here. The railroad tracks at ground level going under the original Long Ravine trestle were the tracks for the Nevada County Narrow Gauge Railroad, which was operational by 1875.

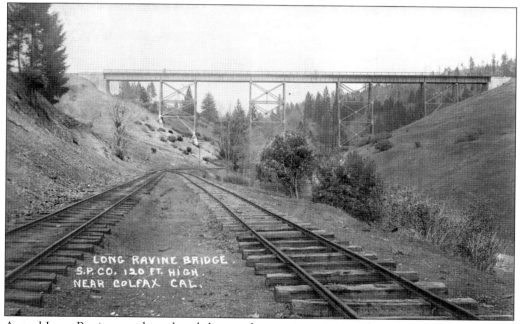

LONG RAVINE BRIDGE.
S.P. CO. 120 FT. HIGH.
NEAR COLFAX CAL.

A steel Long Ravine trestle replaced the wooden version in 1901. The Nevada County Narrow Gauge Railroad now has two parallel sets of tracks (one set was a siding) passing under the Southern Pacific trestle. The Nevada County Narrow Gauge Railroad ceased operations in May 1942.

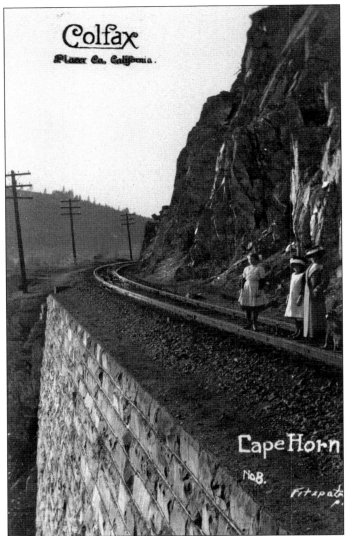

Colfax
Placer Co., California.

Cape Horn
No8.
Fitzpat

Laying tracks around the rock abutment known as Cape Horn a mile east of the Long Ravine trestle was one of the more difficult engineering feats Central Pacific Railroad construction crews faced (until they reached the heights of the Sierra Nevada). Many histories of the Central Pacific Railroad include the story of Chinese laborers being lowered over the side of the cliffs in wicker baskets or bosun chairs attached to ropes. Jack E. Duncan published a study of these claims in his 2005 book, *A Study of Cape Horn Construction on the Central Pacific Railroad 1865–1866*. Duncan graduated from the University of California, Berkeley, as a mechanical engineer, and his work experiences involved photograph analysis, surveying, and the study of foreign construction techniques. Applying these skills to his study of the construction of the tracks laid around Cape Horn, Duncan concluded that the story of Chinese workers being lowered in baskets at Cape Horn was not true. The photograph above shows the 1895 retaining wall built of granite quarried in Rocklin. This wall was much stronger than the original wall built 30 years earlier. The increased weight of modern locomotives (locomotives of the 1890s weighed more than three times those of the 1860s) necessitated the Central Pacific Company's replacement of the original hand-stacked, dry rubble retaining wall with this modern grouted, cut-stone wall.

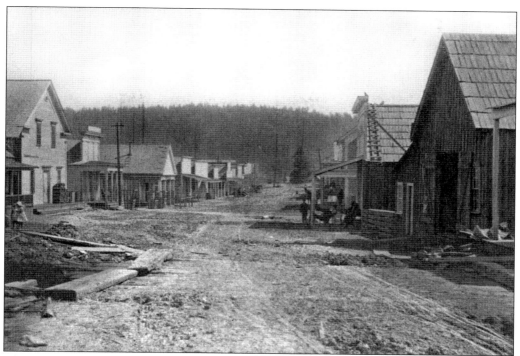

The town of Gold Run is the next community to the east after leaving Colfax. This is an early view of town from 1868. Today there is a Gold Run exit ramp off of Interstate 80, and just east of that off-ramp is a freeway rest stop. (Courtesy of Placer County Museums Division.)

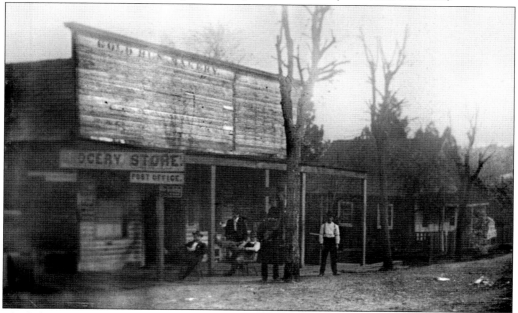

The bakery and post office in Gold Run were located on the town's main street, which ran at right angles to Interstate 80. The few remnants of Gold Run today all parallel Interstate 80. (Courtesy of Placer County Museums Division.)

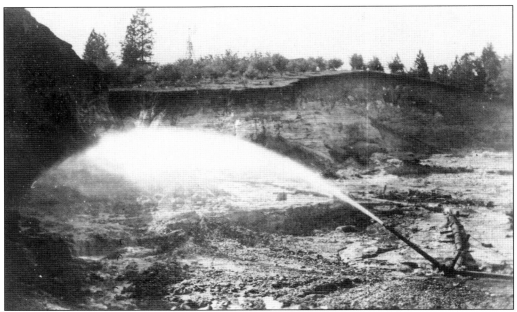

This action shot captures a water monitor in the process of washing away a hillside in the Gold Run area. Much of the dirt from hydraulic mining all over Northern California ended up in the streams and rivers and eventually settled out down on the flat lands of the Sacramento Valley, burying the farmers' crop land. Even after the passing of 100 years, the land that was mined using hydraulic techniques remains scarred.

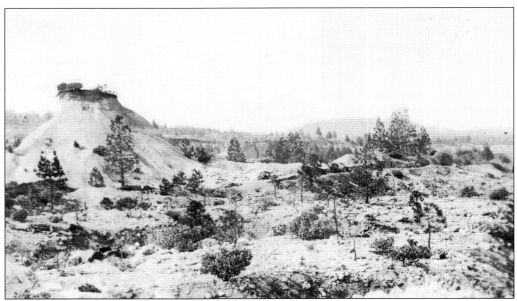

This photograph shows the aftermath of hydraulic mining in the Gold Run area. The image testifies to how much gravel and dirt was blasted out of the hills by the water pressure generated by the water monitors. The soils burying the farmland in the lowlands led to a lawsuit, which was won by the farmers in 1884. As a result, hydraulic mining was significantly curtailed.

Three

MOUNTAINS OF PLACER COUNTY

This third chapter contains scenes of points of interest and communities located in the higher elevations associated with Interstate 80 as it passes through Placer County. These places lie in the elevation range between 3,000 feet around Dutch Flat up the 7,000-foot elevation at the pass over Donner Summit. Not many people lived in the communities at these higher elevations, and this chapter reflects that fact by including more images of singular points of interest than actual towns. Examples of these points of interest are railroad snowplows and the snow sheds covering the railroad tracks. Dutch Flat was and is the only place with much of a population. Places listed in this chapter include Apple Tree Inn, Alta, Baxter, Blue Canyon, Cisco, Dutch Flat, Emigrant Gap, Monte Vista Inn, Rainbow Lodge, Rawhide Mine, Summit, and Towle. Again, as in the previous two chapters, images of the communities will be arranged in a west-to-east order.

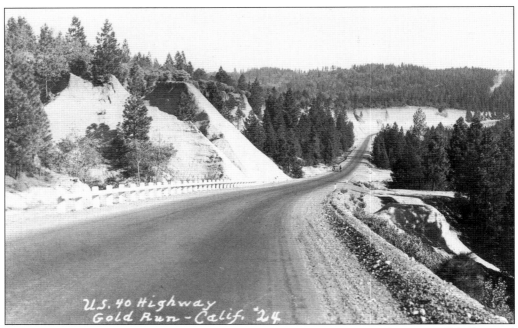

U.S. 40 Highway
Gold Run - Calif. '24

Leaving Gold Run and heading east on U.S. Highway 40, cars start to climb a small hill toward the Monte Vista Inn at the Dutch Flat exit. Automobiles on Interstate 80 still take this route up the same hill, only now it is a four-lane freeway instead of the two-lane highway from the World War II era.

ON HI-WAY U.S. 40 CA

As motorists reached the top of the grade climbing up out of Gold Run, the Monte Vista Inn would be on their left at the turnoff to Dutch Flat. U.S. Highway 40 ran right in front of the main entrance to the restaurant in this 1940s photograph. The Monte Vista Inn stands today and serves food and liquor.

The Dutch Flat train depot was on Sacramento Street, about halfway between the Monte Vista Inn and the town of Dutch Flat. In July 1898, a locomotive exploded while passing in front of the Dutch Flat depot. The train's engineer was killed and thrown 300 yards by the blast.

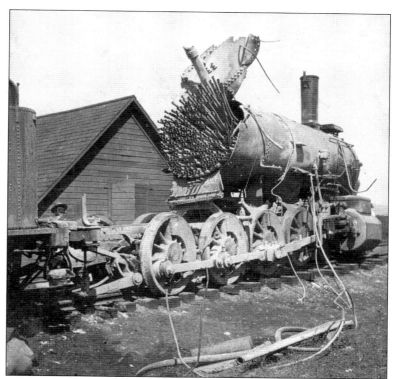

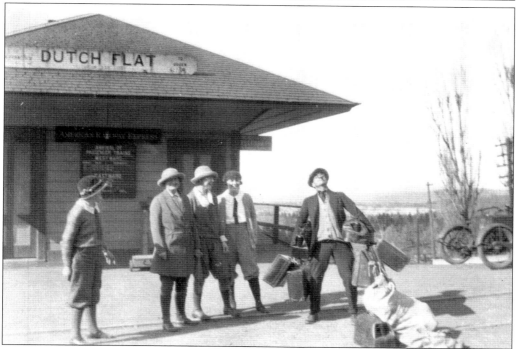

Four young ladies are awaiting the train at the Dutch Flat depot in the early 1930s. The only individual identified in this old photograph is Pearl Stewart, who is second from the left.

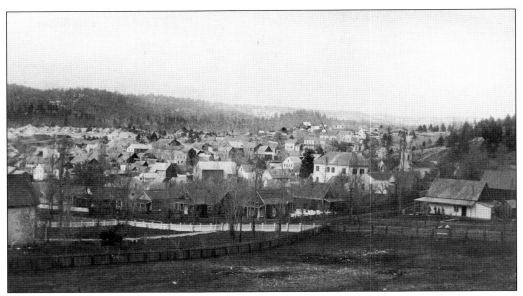

At bottom of the hill, below the Dutch Flat depot, the town of Dutch Flat spreads out on a relatively flat piece of land—thus the name. The white, two-story Dutch Flat grammar school building can be seen at right. Most homes in Dutch Flat were surrounded by fences to keep out the wandering chickens, pigs, and cows owned by neighbors.

A photographer is standing closer to town in this view than the one above, so the field of view is narrower. As in the photograph above, the two-story Dutch Flat grammar school stands at right.

The grammar school building is on the left, and the Dutch Flat Methodist Church is on the right. The photographer for this image was standing in the middle of Stockton Street while looking north between the two buildings.

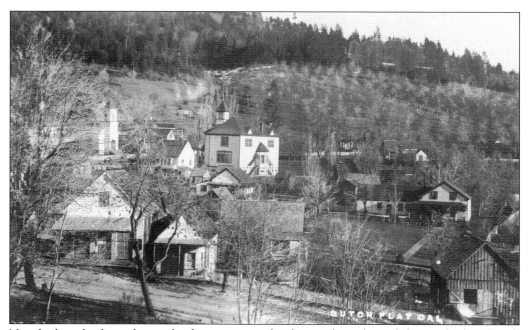

Now looking back southeasterly, the grammar school is on the right and the Methodist church is on the left. Both of these buildings still stand in Dutch Flat after all these many passing years. The school building is now used as a community center.

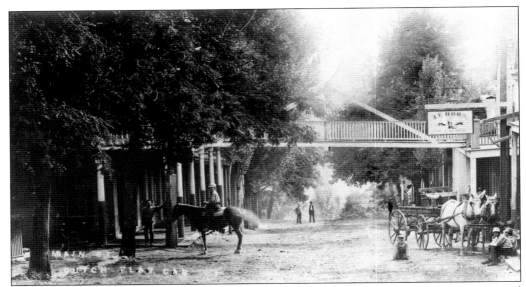

A short elevated walkway was built to bridge Dutch Flat's Main Street. The bridge connected the second floor of the Dutch Flat Hotel on the left with the National Hotel across the street. Both hotels were owned by the same man at the time. The Dutch Flat Hotel still stands and now functions as a bed and breakfast.

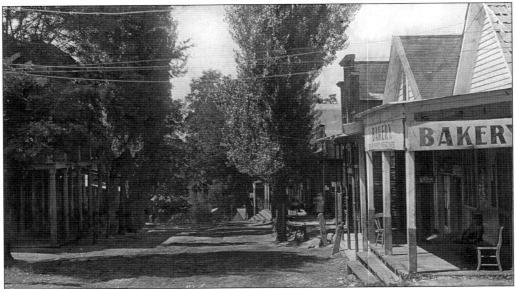

Looking down Main Street in Dutch Flat, a bakery is on the right and the Dutch Flat Hotel is almost obscured by a row of trees on the left. The elevated walkway bridging the street had been torn down by the time this c. 1914 photograph was taken.

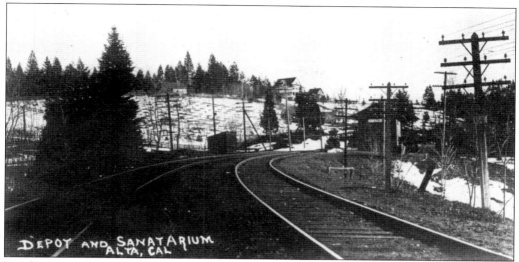

DEPOT AND SANATARIUM
ALTA, CAL

Heading east out of Dutch Flat, the Southern Pacific train tracks start to bend to the right as they approach the small community of Alta and its depot. The Alta Sanitarium sits on the hill in the center of this image. Many mountain communities near the railroad had tuberculosis sanitariums, as the mountain air was considered good therapy for congested lungs.

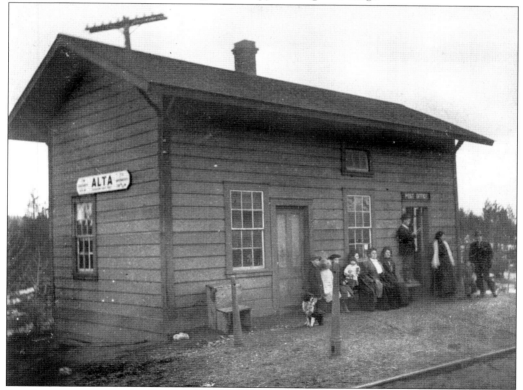

People are waiting for the Southern Pacific train to arrive at the Alta depot, which also served as the local post office. The communities of Alta and Dutch Flat still exist, but neither one has a train depot. Trains long ago ceased stopping at every small community along their routes.

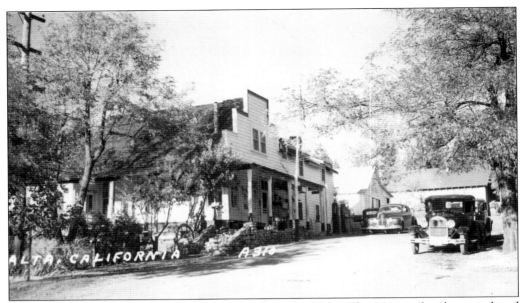

The Alta store was about 50 yards from the depot building. The Murray family owned and operated the store in Alta for many years in the middle of the 20th century. A small vacant lot between the store and depot was the site of an annual Easter egg hunt in the 1950s, sponsored by the Murray store.

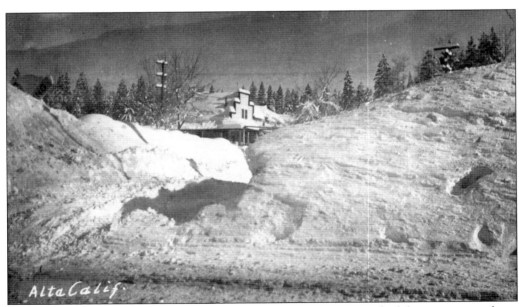

The store at Alta is almost buried by the snowfall, which was typical of the winter months at this elevation of 3,500 feet. The Alta store seen in the two photographs on this page is still open for business.

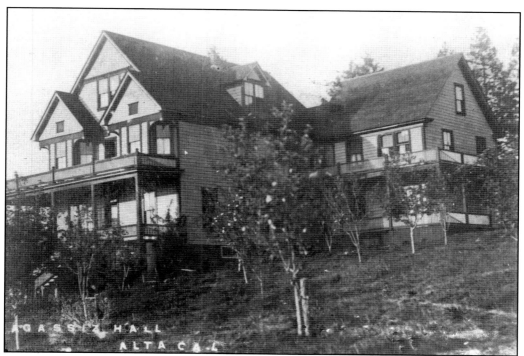

In the early 1900s, the Agassiz Hall in Alta served as a boys school for some of the more wealthy families in Northern California. The school was moved down to Auburn in 1909, and this building in Alta was taken over by the White Crusaders and converted into a tuberculosis sanitarium. Tuberculosis was also known as the "Great White Plague" and "consumption."

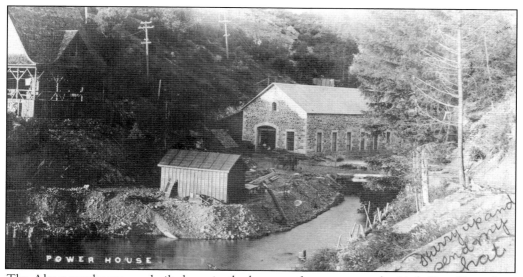

The Alta powerhouse was built down in the bottom of a canyon on the Little Bear River. It is part of the Pacific Gas and Electric Company's electric power development program on rivers and streams throughout Placer County and Northern California.

A man is seen standing between the tracks in the middle of the Towle Brothers lumber facility at Towle. Past that man, around the curve in the Southern Pacific Railroad tracks and at a half-mile's distance, is the Alta depot.

This is the view that the man standing between the tracks would have had of Towle. The Kearsarge Hotel (and boardinghouse) is on the right. The Towle store is on the left. All of the buildings shown in this group of Towle images are now gone.

The Kearsarge Hotel at Towle is covered in winter snow. The little building in the middle of this image is the Towle depot. The distance between the Dutch Flat, Alta, and Towle depots was less than 5 miles.

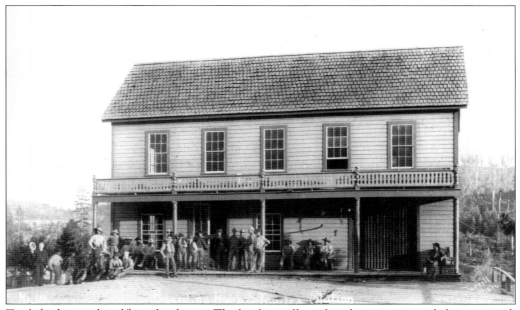

Towle had a nice hotel/boardinghouse. The lumber mill employed many men, and if not married, they probably preferred staying in this company boardinghouse when in town. This photograph was taken by Charles Beebe Turrill, who was a famous photographer from San Francisco. (Courtesy of Society of California Pioneers.)

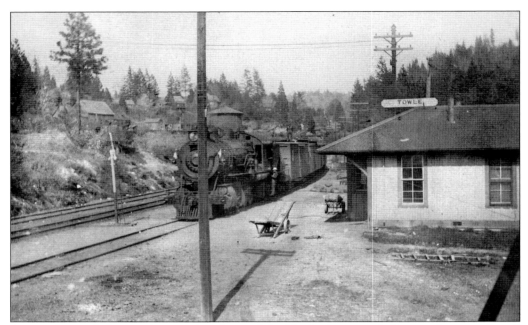

A train has pulled up and stopped in front of the Towle depot, probably to take on or let off passengers, mail, and goods for the store. The Towle depot was converted to a Southern Pacific signalman's house and was home to this book's author from 1950 through 1955.

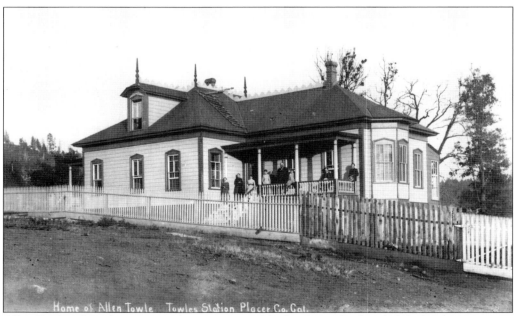

Allen Towle, whose home is seen here, was one of the brothers who founded the lumber company. A post office served Towle from 1891 to 1936. Some early maps and other sources called the place Towles Station. "Towles" was probably used because of the plurality of the brothers who founded the company. This is another image taken by Charles Beebe Turrill. (Courtesy of Society of California Pioneers.)

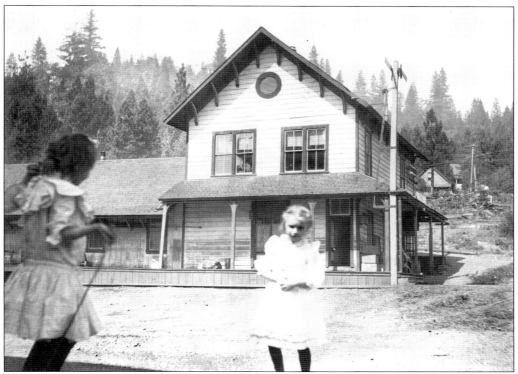

Across the tracks from the depot was the Towle store. The road seen immediately to the right of the store wound around behind the store and up the hill to Alta. The girl at left is jumping rope.

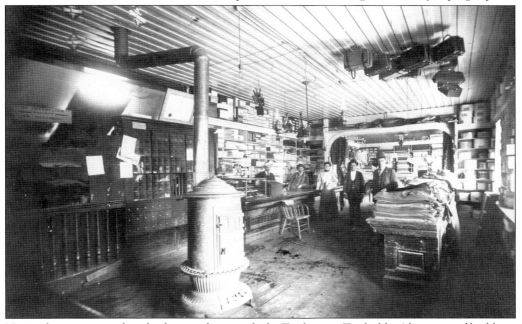

Notice the prominent place for the stove here inside the Towle store. Towle, like Alta, received building-burying snowfalls in the winter months, and a stove was necessary to ward off the cold.

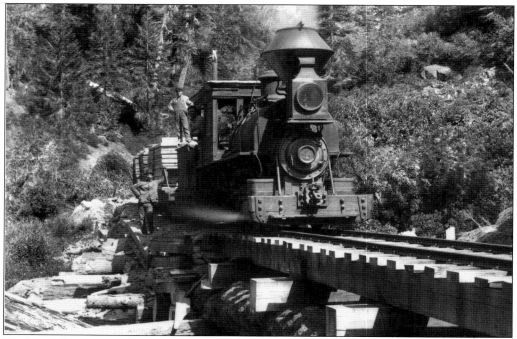

Towle Brothers built a narrow-gauge railroad that wound through the rough terrain for a twisting length of 30 miles on the property leased and owned by the company in both Placer and Nevada Counties. Here one of the Towle Brothers' small narrow-gauge locomotives is hauling out a load of rough-cut lumber from an outlying sawmill to Towle for further processing.

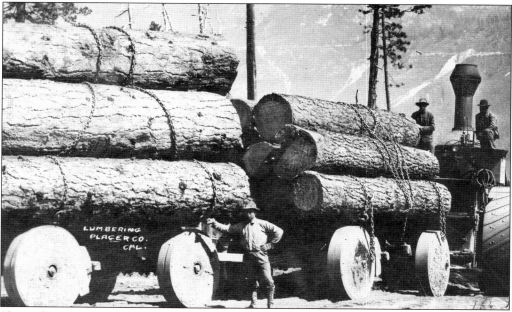

Shown here was another means used to haul fallen trees out of the forest to a nearby sawmill. These huge tree trunks were hauled out by the steam-powered tractor seen at far right. Prior to the use of steam tractors, large teams of oxen were used to haul out the fallen trees.

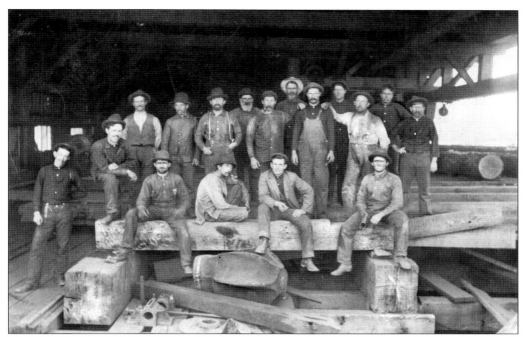

Inside one of the Towle Brothers Company sawmills is a group of mill hands posing for a photograph. Notice the large dimensions of the milled logs that the men are sitting on for this photograph. These large timbers might have been used in construction of trestles for the Towle Brothers' narrow-gauge railroad (see the photograph on the opposite page).

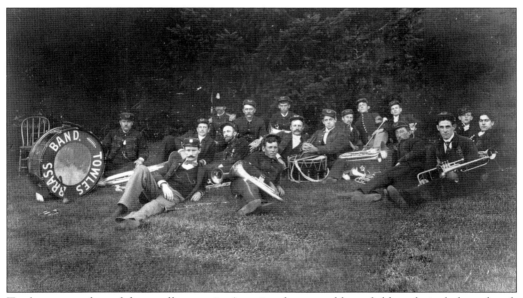

Towle was another of the small towns in America that was able to field a relatively large band. Here is the Towles Brass Band posing for a group photograph. The name on the drum reflects how sometimes the community was known as Towles and at other times was called Towle.

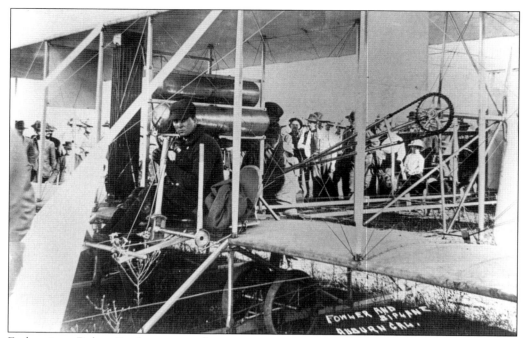

Early aviator Robert Fowler attempted to win newspaperman William Randolph Hearst's $50,000 prize for the first coast-to-coast airplane flight made in 30 days or less. Fowler had taken off from San Francisco on the afternoon of September 11, 1911, hoping to reach Colfax before it got dark. He only made it to this field in Auburn, though, on that first day.

Fowler crashed his plane among trees near Alta on September 12, 1911. People from Alta, Towle, and Dutch Flat gathered to see the wreck. Fowler was not hurt. The plane was repaired in Colfax. After Fowler's subsequent attempt to cross the Sierra Nevada also failed, he decided to try starting his cross-country trip in Los Angeles.

The note on the back of the Fowler postcard at the bottom of the previous page has a message about the Rawhide Mine, which was located in a canyon near Towle. On December 10, 1911, Calbraith "Cal" Rodgers—not Fowler—completed the first cross-country flight, having flown from east to west. Rodgers missed Hearst's one-year deadline, however, and did not win the prize money.

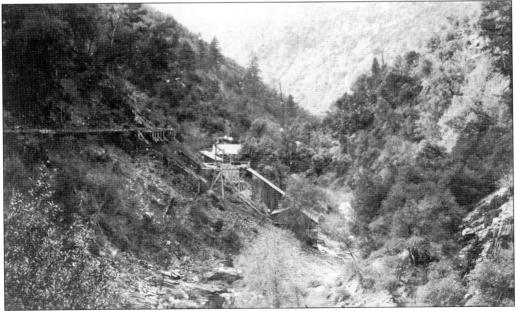

The Rawhide Mine sat right above the waters of the North Fork of the North Fork of the American River. This photograph shows the buildings in which the ore was processed. The ore was brought down to the processing buildings from the mine tunnels higher up on the canyon wall. The impressive 2,400-foot sheer cliff known as Lover's Leap is located 3.5 miles downstream from the mine.

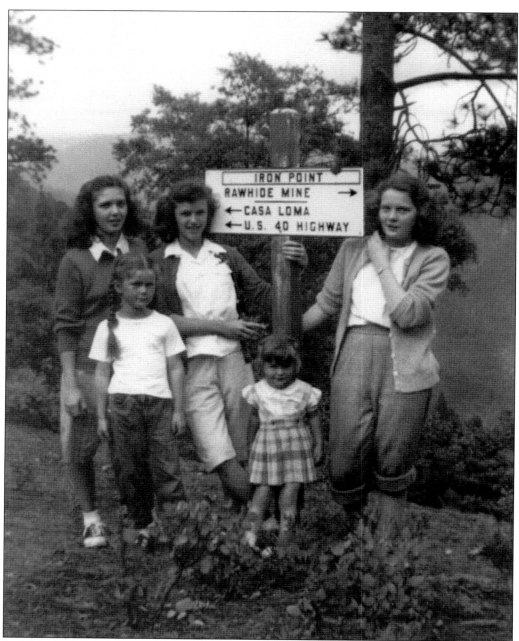

In 1949, these five young ladies posed on the road to Casa Loma, due east of Towle, by the road sign at Iron Point. The sign points to Casa Loma, U.S. Highway 40, and the Rawhide Mine, which was down at the bottom of the American River Canyon, 2 miles upstream. The girl with pigtails is Sharon Sommers, the littlest is Mary Michael "Mike" Sommers, and the teenager at far right is Patricia Judge. Sharon and Mike are the author's sisters; Patricia is his cousin. Later, Sharon worked briefly as a waitress at the Baxter's restaurant and as the lifeguard at the Dutch Flat pool. She ended up teaching, as did her cousin Patricia. Mike owned and operated a private school in Auburn in 1999 and 2000.

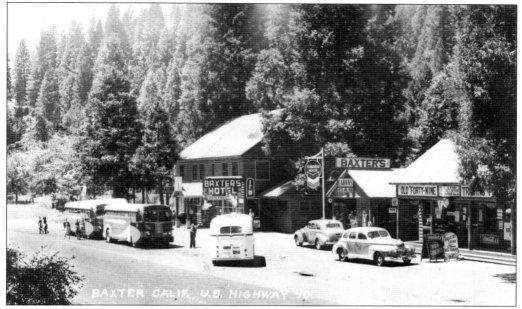

Baxter's was located on the Lincoln Highway and then U.S. Highway 40 northeast of Towle. Baxter's was originally known as Baxter's Camp back when it was a rest stop for early travelers on the Lincoln Highway. Much of the Lincoln Highway's route was redesignated U.S. Highway 40. Baxter's remained a popular stopping place for motorists for many decades.

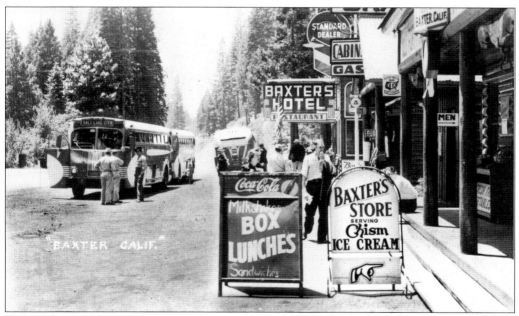

U.S. Highway 40 bypassed the communities of Dutch Flat, Alta, and Towle. Baxter's remained a primary rest stop for people in their cars and all the buses traveling up and down U.S. Highway 40. Baxter's was a popular trucker's stop into the 1980s, but the last of the buildings were destroyed by a 1998 fire. There is nothing left of the original Baxter's.

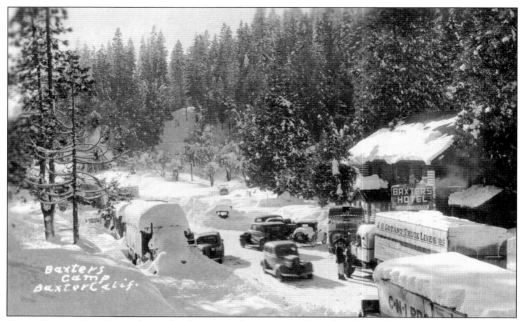

Baxter's was the place where the highway department closed U.S. Highway 40 when the deep snowfall shut down travel over Donner Summit. There was actually a rather flimsy gate that could be swung across the highway to stop motorists from trying to continue east.

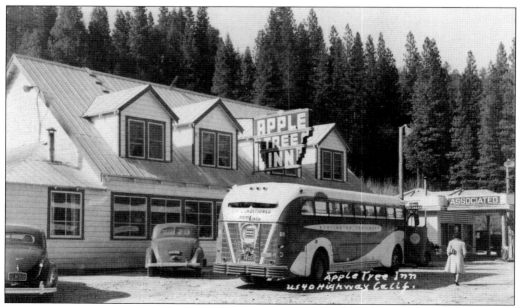

The Apple Tree Inn was less than a half mile from Baxter's, but it never saw the same amount of business that Baxter's did.

Less than 5 miles east of Baxter and the Apple Tree Inn was the location of the original Auburn Ski Club's ski jump hill. A news article from the *Placer Herald* of October 18, 1930, mentioned that hundreds of cars would be parked along U.S. Highway 40 on some Sundays while the occupants were watching the ski jumpers. In 1931, the Auburn Ski Club relocated their jump hill up the road near Cisco.

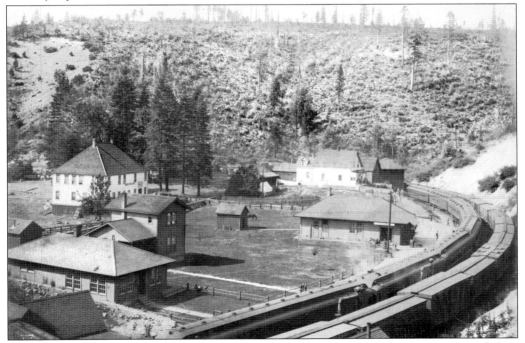

Blue Canyon is famous now as the place where each year many television companies send their news personnel to report on the winter's snowfall. Blue Canyon is at 5,000 feet in elevation. In this old picture, both an eastbound and westbound train are stopped in front of the depot at Blue Canyon.

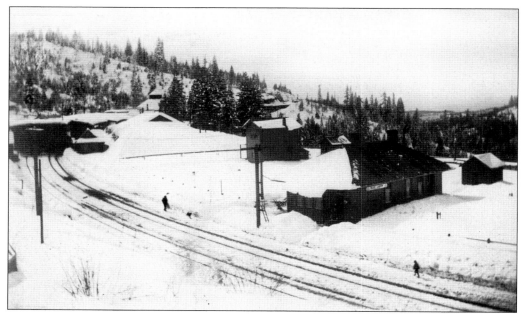

On the far left, the entrance to the beginning of the snow sheds can be seen in this view of a part of Blue Canyon covered in snow. Approximately 30 miles of wooden snow sheds were built to keep the tracks clear of the winter snow, which got very deep above 5,000 feet.

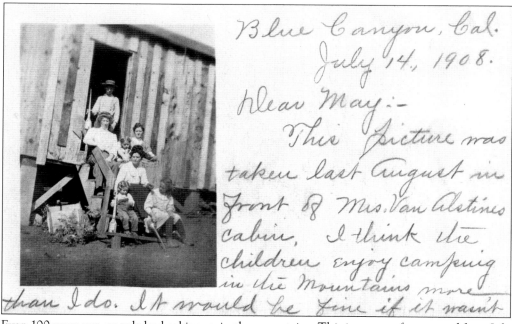

Blue Canyon, Cal.
July 14, 1908.
Dear May:-
 This picture was taken last August in front of Mrs. Van Alstines cabin. I think the children enjoy camping in the Mountains more than I do. It would be fine if it wasn't

Even 100 years ago, people had cabins up in the mountains. This is a copy of a postcard from July 1908. The note says that the photograph was taken the previous August. The note continues on the back of the card and says "it would be fine if it wasn't so dirty."

Blue Canyon had a small population, mostly men working on the Southern Pacific Railroad. There were enough children, though, for Blue Canyon to have its own one-room schoolhouse.

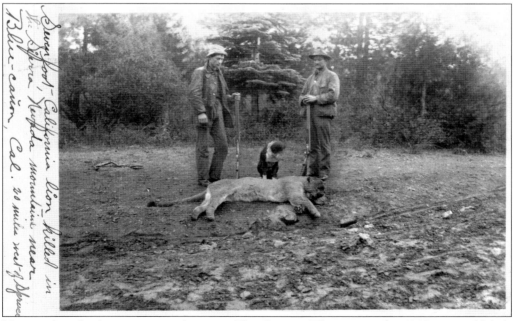

Hunters shot this large mountain lion near Blue Canyon. The note on this 1907 postcard labels the 7-foot-long cat as simply a "California lion."

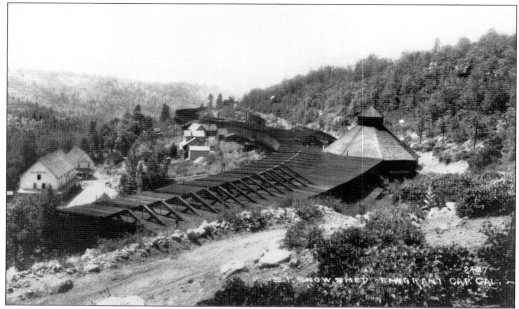

Emigrant Gap was another mountain community dependent upon the railroad. In this early view, the snow sheds can be seen covering all the exposed tracks above the town's buildings. The round roof on the building at right was covering a 65-foot turntable, which was abandoned by the railroad in 1922. This photograph was taken by Theodore C. Wohlbruck.

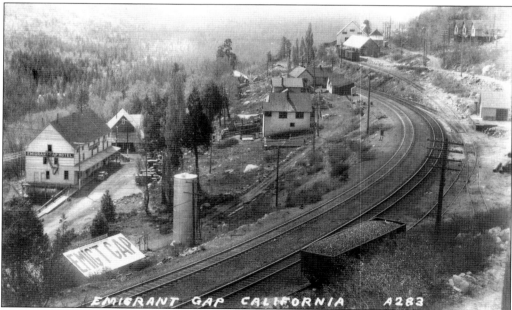

A view of the community of Emigrant Gap later than the one above shows that the snow sheds had been removed. The wooden sheds needed constant repair and often caught fire from burning embers ejected out the smokestacks of the wood-burning locomotives. The sheds were an expensive solution to the heavy snowfall in the mountains.

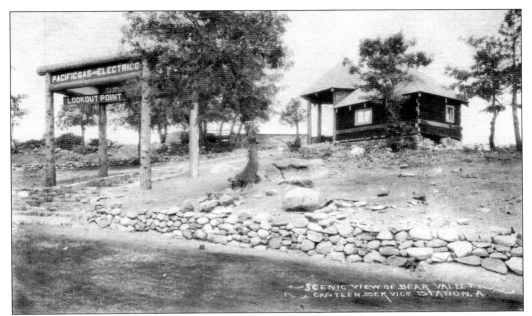

On the heights above Emigrant Gap was a point where the Pacific Gas and Electric Company built a lookout for motorists. The lookout gave a view down into Bear Valley and Lake Spaulding. The Lincoln Highway roadbed passed right in front of the large sign. This image and the one below were taken by Theodore C. Wohlbruck.

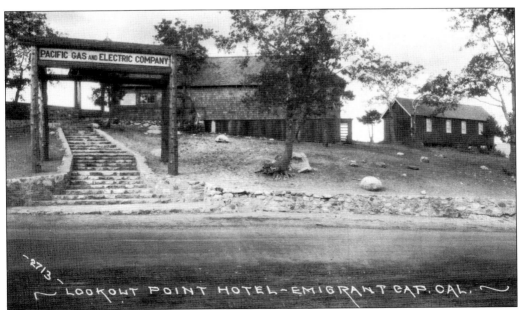

The Pacific Gas and Electric Company's lookout on the ridge above Emigrant Gap started with just a simple food canteen. The facilities expanded over time until even a small hotel was part of the group of buildings on the heights overlooking Emigrant Gap on one side and the Bear Valley on the other side.

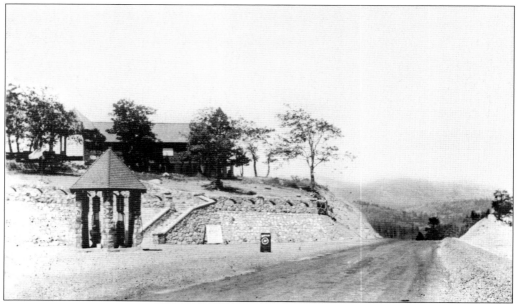

The Lincoln Highway roadbed can be seen much better in this photograph. A gasoline pump has been installed at roadside. The stone steps lead up to the lookout point where the food canteen and hotel stood. Both were owned and operated by photographer Theodore C. Wohlbruck. Wohlbruck took class photographs at many of the schools along the old Lincoln Highway/U.S. Highway 40 route between Sacramento and Truckee.

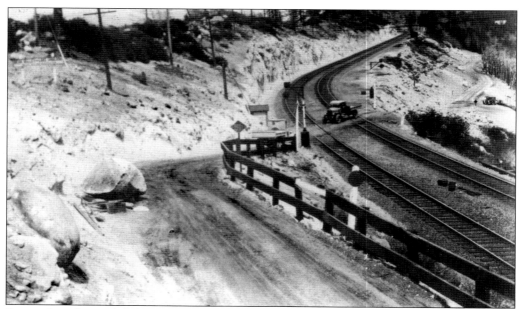

Descending the grade below the Pacific Gas and Electric lookout, a traveler had to make a sharp turn to the right to cross over the Southern Pacific Railroad tracks. Railroads typically had priority in the days of the Lincoln Highway. The Southern Pacific Company was reviled by many in California as a monopoly, with its octopus-like tentacles in everybody's business.

The Pacific Gas and Electric lookout shut down prior to World War II, and the new Nyack Lodge was built near the same spot after World War II. This image shows the Nyack Lodge under construction on a point overlooking the Bear Valley and Lake Spaulding. This building was torn down, and Nyack relocated across the freeway when Interstate 80 was being widened in the early 1960s.

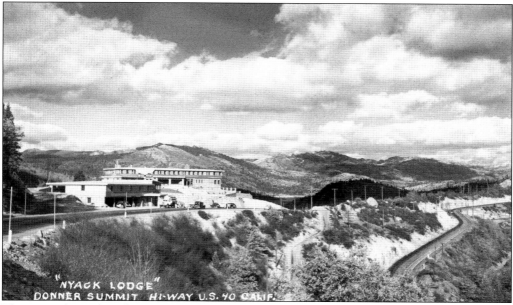

The original Nyack Lodge is seen here after completion. A large gas station can be seen at left and a little below the lodge. The community of Emigrant Gap is just out of the picture to the right.

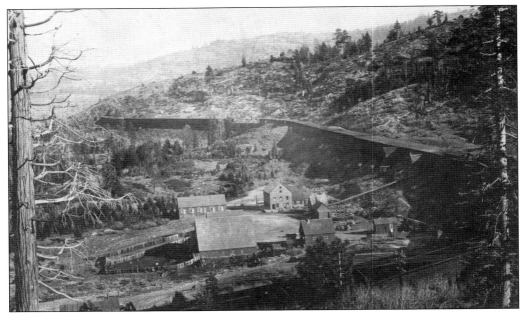

Heading higher into the mountains, past Emigrant Gap, on the highway or railroad tracks east, a traveler would reach Cisco. This view is looking east down on the community of Cisco. Cisco was originally associated very strongly with the construction of the railroad. Now travelers heading up over the summit on Interstate 80 usually bypass the Cisco exit unless they need gasoline.

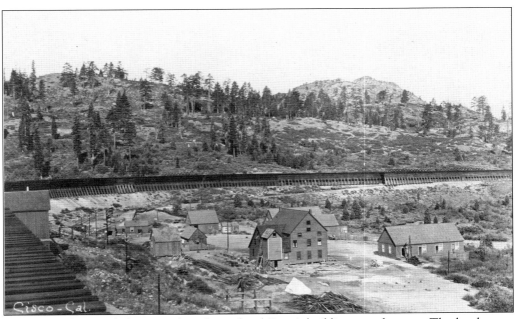

Looking back toward the west, the other side of Cisco's buildings can be seen. The level, open space in the lower right corner of this image was later to be the site for tents set up for early automobile travelers taking the Lincoln Highway.

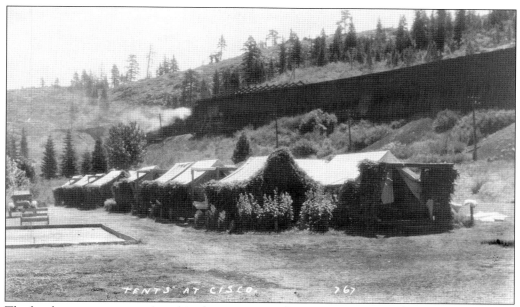

The level, open space mentioned in the caption on the previous page now has the tents erected for automobile campers. This automobile campsite is another indication that travel by rail was being supplanted by the automobile.

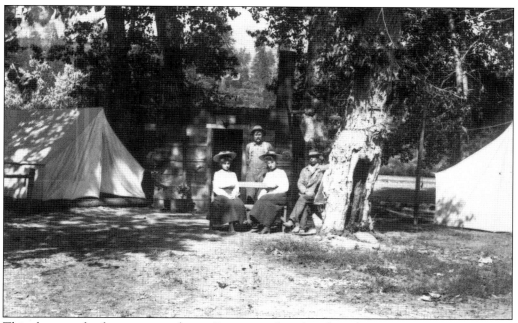

This photograph of a campground near Cisco is much earlier than the tent camping spot pictured above and a little removed in distance from the automobile travelers's "tent city" at Cisco. This image is from a print made off of a glass-plate negative.

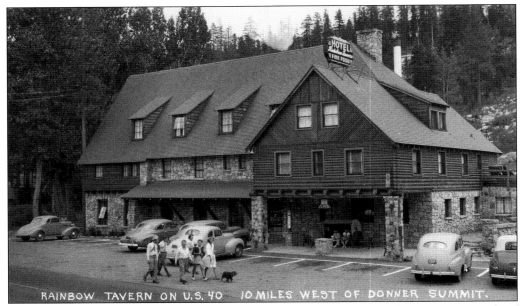

RAINBOW TAVERN ON U.S. 40 10 MILES WEST OF DONNER SUMMIT.

The Rainbow Lodge was built in 1927. The people walking with their dog are just a couple of feet off the roadbed of U.S. Highway 40. Safety considerations were lax in those days. The rear bumpers of cars parked in front of the lodge are only a few feet away from passing cars.

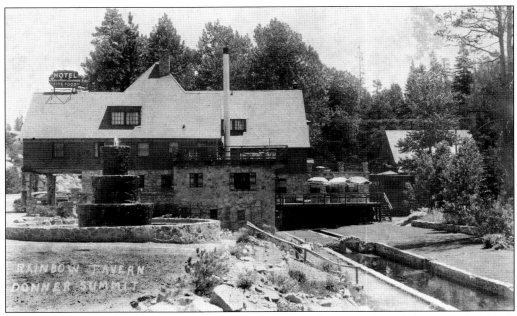

RAINBOW TAVERN
DONNER SUMMIT

A side view of Rainbow Lodge shows the rear porch and the "trout farm" fish pen built of rock in the lower right corner. This building has survived. It is still functioning as a hotel and has a well-reviewed lunch and dinner menu.

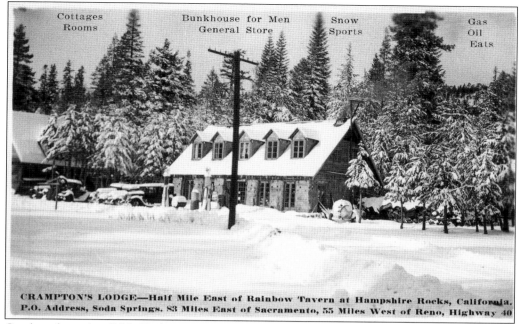

Cottages Rooms Bunkhouse for Men General Store Snow Sports Gas Oil Eats

CRAMPTON'S LODGE—Half Mile East of Rainbow Tavern at Hampshire Rocks, California. P.O. Address, Soda Springs. 83 Miles East of Sacramento, 55 Miles West of Reno, Highway 40

On the other side of U.S. Highway 40 and heading east up the road from the Rainbow Lodge was Crampton's Lodge. Crampton's Lodge was situated near the border between Placer County and Nevada County. The route of the railroad and the highway often crosses back and forth between Placer and Nevada Counties at these higher elevations.

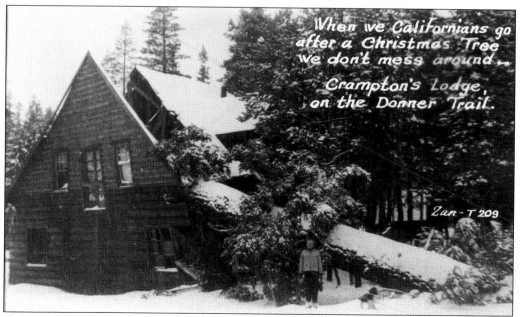

When we Californians go after a Christmas Tree we don't mess around... Crampton's Lodge, on the Donner Trail.

Zan - T 209

Crampton's Lodge was located across the road from the Hampshire Rocks campground on the South Fork of the Yuba River. Crampton's was another victim of the widening of Interstate 80. This fallen tree probably did not help the lodge's future either.

101

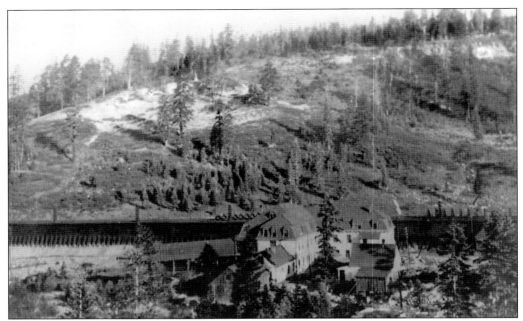

The trip up through the Sierra Nevada in this part of Placer County reaches the highest point of crossing at Donner Summit. The Summit Hotel was located in the small community of Donner. There were 49 registered voters claiming Donner as their home in 1908. Most of the voters listed occupations associated with the railroad, but a few listed their job as working at the hotel.

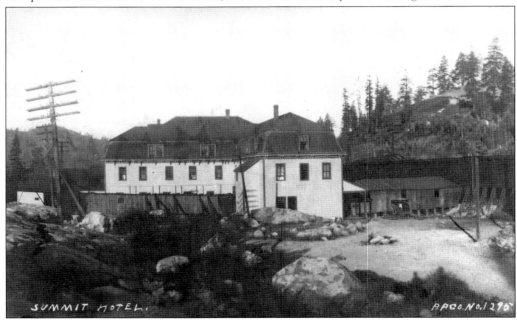

This view of the side of the Summit Hotel shows a covered walkway joining a door of the hotel with an entrance in the side of the snow sheds. During the winters of 1879–1880 and 1889–1890, over 60 feet of snow fell at the summit, and even all the many miles of snow sheds could not keep the snow from blocking the trains for days at a time.

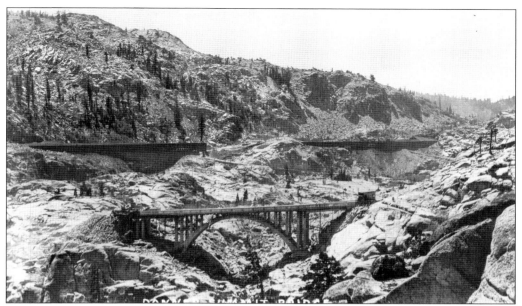

Still heading farther east, just past the Summit Hotel, travelers on U.S. Highway 40 would start descending down to Donner Lake. The famous Donner Summit Bridge (Rainbow Bridge) can be seen under construction in this photograph. The photographer is standing in Nevada County and the Rainbow Bridge is in Nevada County, but the snow sheds cutting across the middle of this image are in Placer County.

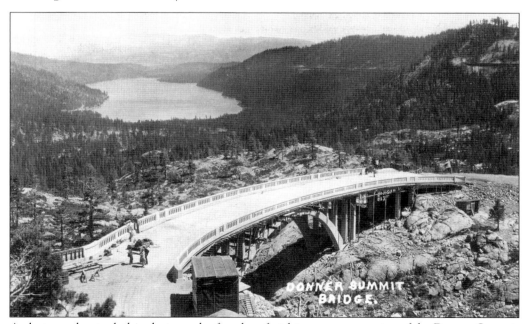

A photographer took this photograph of workers finishing up construction of the Donner Summit Bridge. This bridge started being used in 1926 as part of an improved route for the Lincoln Highway over Donner Summit. The bridge and Donner Lake sit in Nevada County, but the snow sheds seen as a horizontal line along the cliffs on the right lie inside Placer County.

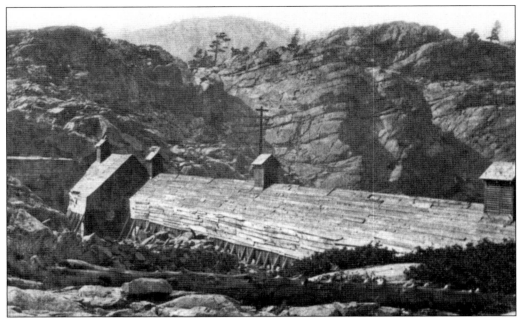

The trains crossing the Sierra Nevada during the early years burned cords of wood to fire up the steam boiler to provide power to the wheels. The burning wood produced a lot of smoke. Chimneys were built at intervals in the peaked roof of the snow sheds to vent the smoke. The peaked-roof design was soon abandoned, though, as the accumulation of snow on the uphill side of the sheds would push them out of alignment.

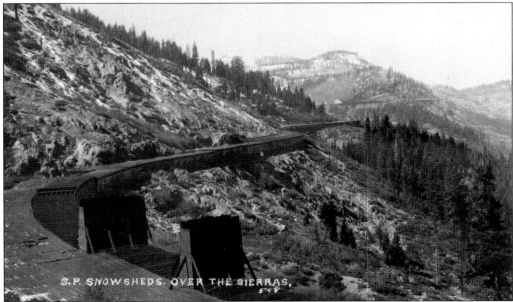

A later design used for the almost 30 miles of snow sheds covering the Southern Pacific tracks up over the summit shows that the roof has been flattened and the chimneys removed. The train engineer's cab was moved to the front of the locomotive in 1908 to put him in front of the smoke generated by the burning wood. This style of locomotive became known as the cab forward engine.

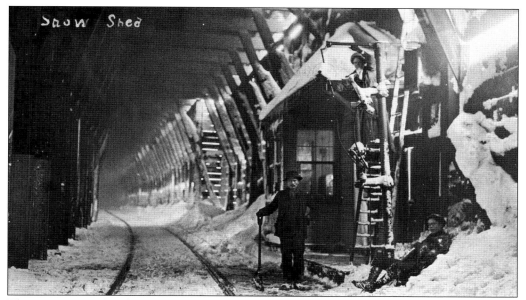

The movement of early trains was controlled by sending signals up and down the tracks from signal shed to signal shed to depots. The signal shacks were even built inside the 30 miles of almost continuous snow sheds. Notice that the person climbing the signal pole is a woman in her long Victorian dress.

Snow sheds snake around the mountain curves near Andover. Andover derived its name from a Southern Pacific division superintendent who named the location after his hometown in Massachusetts. By 1873, approximately 30 miles of wooden snow sheds had been built using over 44.6 million board feet of sawed timber and over 1.3 million lineal feet of round timber.

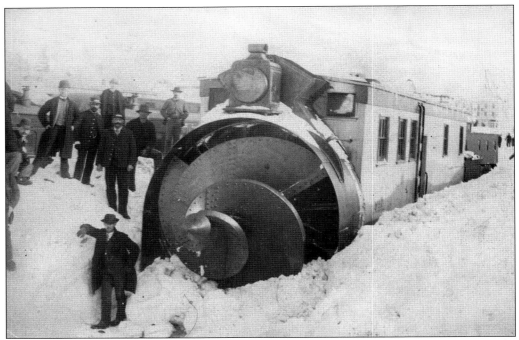

The Cyclone was a short-lived attempt to develop a snow removal machine that could clear the tracks of the heavy snowfall in the Sierra Nevada mountains. This screw device was not very effective, though, as it simply dug a hole in the snow. (Courtesy of Dana Scanlon.)

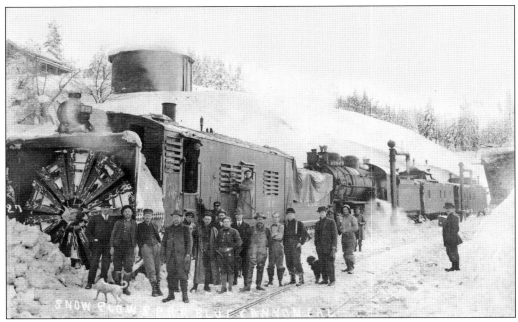

This rotary device on front of the locomotive became the standard design for removal of snow from the tracks. The rotary plow threw snow up and off to the side. Trains also used large metal "flangers" that protruded out from the side of the locomotives to push the snow out of way.

Four

FOREST HILL DIVIDE

The fourth and final chapter in this book includes images of places on the Forest Hill Divide. The Forest Hill Divide is located between the North and Middle Forks of the American River. The divide extends all the way east from Auburn to the Placer County shore on Lake Tahoe. This final chapter includes communities and mining operations of Barton Mine, Bullion, Butcher Ranch, Damascus, Deadwood, Forest Hill, Herman Mine, Iowa Hill, Lake Tahoe, Last Chance, Michigan Bluff, Red Point Mine, and Sunny South.

In this book, the name Forest Hill is split into two words to reflect the original spelling of the place. It was not until 1895 that the two words were merged, resulting in the current spelling as Foresthill. The joining of the two words was officially accomplished by the U.S. Post Office. Whereas in the previous three chapters of this book, the railroad played a significant factor in the founding and continued existence of many communities in Placer County, the Forest Hill Divide part of Placer County had terrain too rugged for railroads. The founding of the majority of the Forest Hill Divide communities was associated with mining and logging. The first chapter began with the small community of Riego, in the most extreme southwest corner of Placer County; this chapter and the book end with a photograph of the Cal-Neva resort and gambling casino, located in Placer County's northeast corner.

A close-up view of the stage stop at Butcher Ranch shows that, in 1890, the location seemed to be more a ranch than it was a town. However, the community of Butcher Ranch claimed 250 residents at its height. Butcher Ranch had its own post office from 1871 through 1935. (Courtesy of Placer County Museums Division.)

Martha Maither and her daughters Mary Etta Maither and Margaret Victoria Maither of Butcher Ranch are posing for a photograph taken by the Middlemiss photography studio in Auburn. The head of the household, Archibald Maither, was a miner.

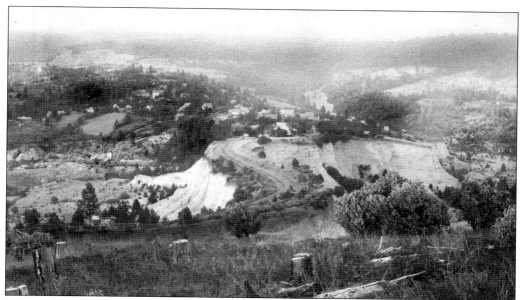

The small town of Iowa Hill is off in the distance across the narrow isthmus of road in the center of this image. Hydraulic mining of the gravel almost completely washed away the road. Iowa Hill is still so remote and isolated because of poor roads that mail is only delivered three times a week. Cell phone reception is poor to this day.

A stagecoach is being readied to leave Iowa Hill on the road that led west to Colfax and south to Forest Hill. Iowa Hill is north of Butcher Ranch.

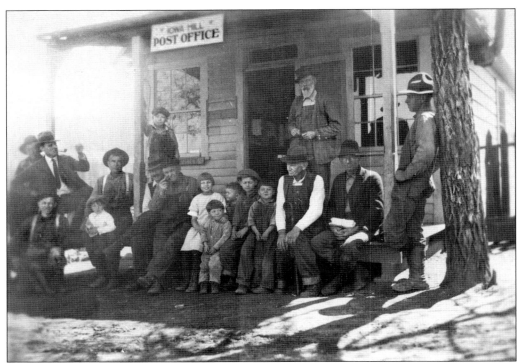

The small building shown here served as the Iowa Hill Post Office. As of 2009, the town of 200 received mail only three days a week.

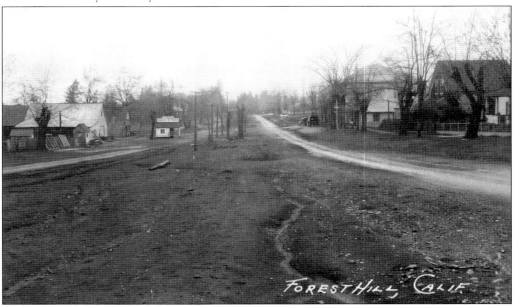

Forest Hill lay south of Iowa Hill. Originally, the town's name was two words; they eventually merged to create the current spelling of Foresthill. Various anecdotes claim to tell why the main street of Forest Hill is as wide as it is, from dreams of greatness to the pragmatic desire to be able to turn a team of horses around. Whatever its origin, the wide street dominates in many images of Forest Hill.

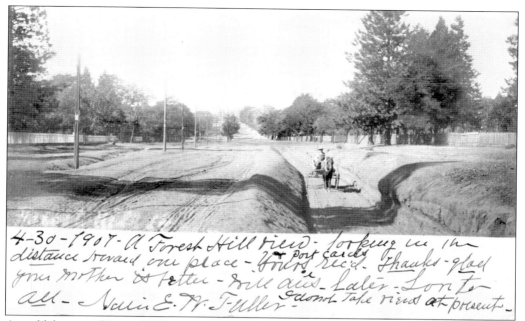

An odd feature of Forest Hill's main street was this deep rut. Nellie Fuller wrote a note on the front of this postcard, which she mailed back to Varysburg, New York, in 1907. Fuller says in the note that her place is just up the road from where this picture was taken.

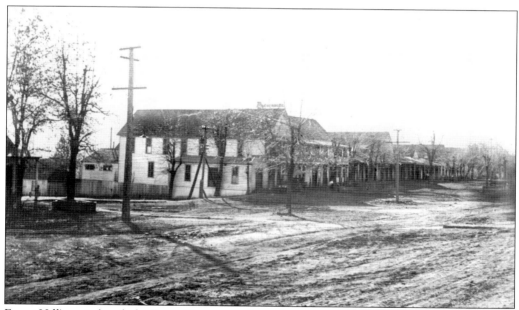

Forest Hill's main hotel, the Forest House, stands on the corner in this photograph. It is no surprise that fires were destructive to towns when the inhabitants erected all of these wooden buildings right next to each other and open flames were often used for light and heat.

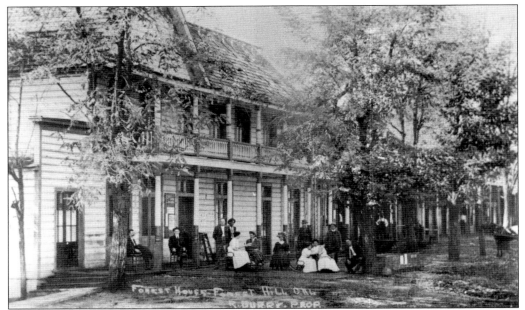

This is a close-up of the Forest House hotel. The original structures of Forest Hill were built down on the hillside above American River, but the Forest House hotel was built at the top of the ridge and everyone else soon followed; the whole town eventually relocated to the top of the canyon ridge. This hotel burned down in December 1918.

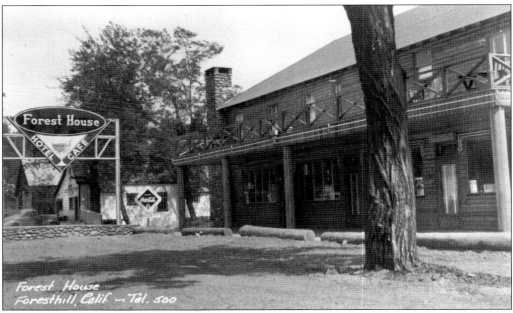

Here is a photograph of the more recent version of the Forest House hotel in Forest Hill.

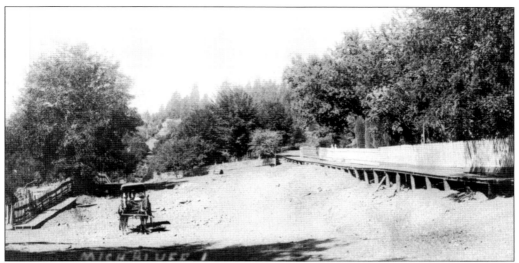

Michigan Bluff is famous for being the hometown of Leland Stanford before he moved to Sacramento and became part of the "Big Four" responsible for the construction of the Central Pacific Railroad. Though smaller than Forest Hill, Michigan Bluff looks also to have had some wide streets.

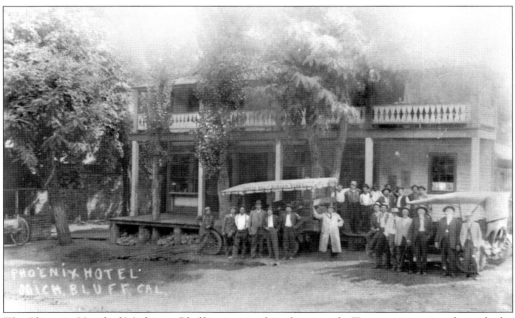

The Phoenix Hotel of Michigan Bluff is seen in this photograph. Trees are growing through the front porch of the hotel.

In the 1850s, Leland Stanford operated a store in this stone building in Michigan Bluff. This photograph was taken about 50 years after Stanford joined with Collis P. Huntington, Mark Hopkins, and Charles Crocker, forming the Big Four who raised the money to build the Central Pacific Railroad. He later founded Stanford University. (Courtesy of Dana Scanlon.)

Two of Michigan Bluff's early pioneers sit for a photograph on a wooden sidewalk. Noah Hough (left) was a teamster. Lee Van Eman worked as a miner.

114

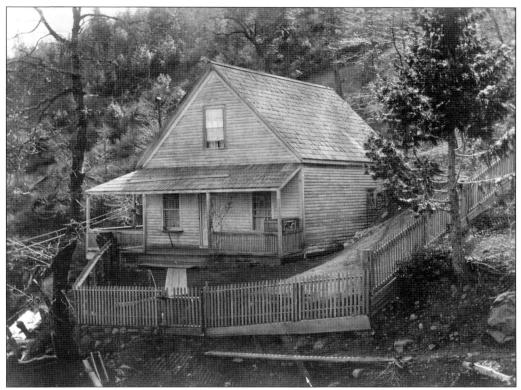

William Cameron, who along with Michael Power discovered the Hidden Treasure Mine in 1875, had this modest home in the community of Sunny South. The Hidden Treasure Mine produced gold for 35 years and was one of the richest mines on the Forest Hill Divide.

All of Sunny South was built on the side of a steep canyon wall to be near the portal of the Hidden Treasure Mine's tunnel. The town of mostly mine workers was located on the side of the canyon that was facing south and was warmed by the sun, thus the town's name.

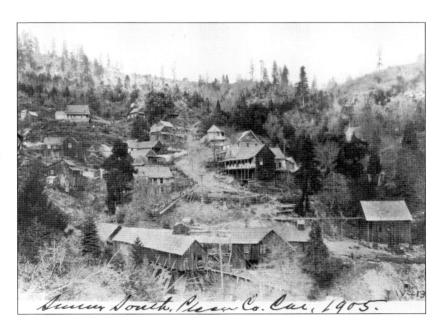

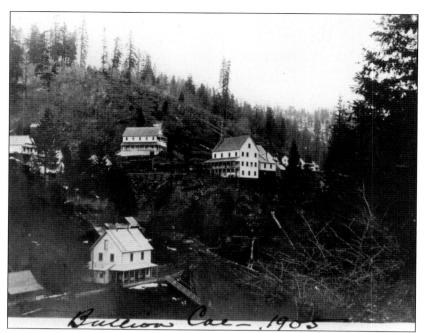

The town of Bullion was built at a new opening into the Hidden Treasure Mine's tunnel a couple of miles from Sunny South. Many of the mine workers moved from Sunny South to the new town of Bullion. Like Sunny South, Bullion was built right on the steep slope of the canyon wall.

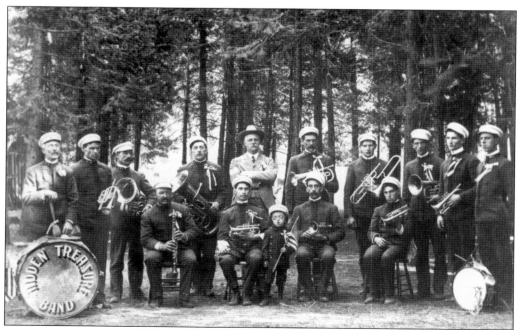

Members of the Hidden Treasure Band are posing for a group photograph. Bands were usually named after the community; however, this band chose to name itself after the mine in which most of the band members probably worked.

The small community of Deadwood was less than 2 miles from Sunny South. In the Placer County register of voters for 1908, not one male gave his address as being in the town of Deadwood. The building in this photograph served as the hotel for Deadwood. (Courtesy of Placer County Museums Division.)

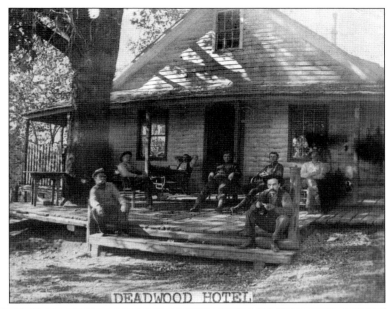

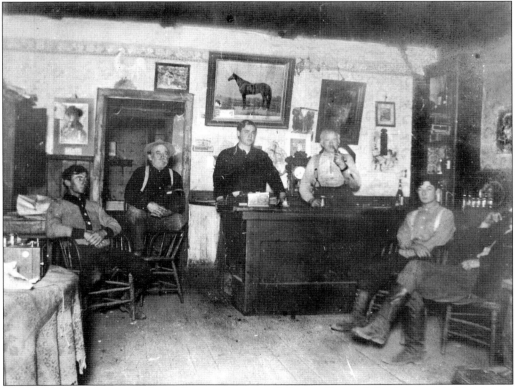

Bars have always been popular gathering places, and the small size of this barroom in Deadwood indicates how few people lived in the town. Besides this Deadwood and the more famous one in South Dakota, there were also Deadwoods in Sierra County and Tuolumne County. (Courtesy of Placer County Museums Division.)

Though a very small community, Deadwood had its own one-room schoolhouse, seen above. It was originally a miner's cabin. (Courtesy of Placer County Museums Division.)

Even the smallest towns would try to muster up a baseball team and maybe a brass band. Seen here is the baseball nine in the small community of Damascus, located a couple of miles north of Sunny South. (Courtesy of Placer County Museums Division.)

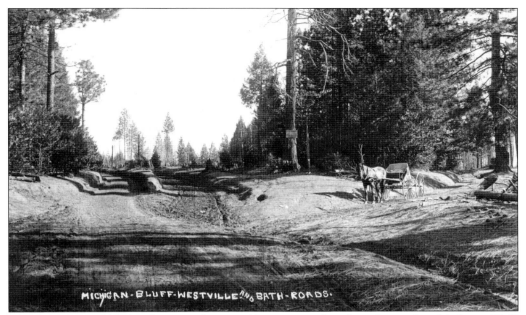

It looks like it would be hard to turn a horse and buggy around on these dirt roads to Michigan Bluff, Westville, and Bath. Wagon wheels carved deep ruts in the soft dirt. The photographer of this image has left his horse and buggy in the frame. (Courtesy of Placer County Museums Division.)

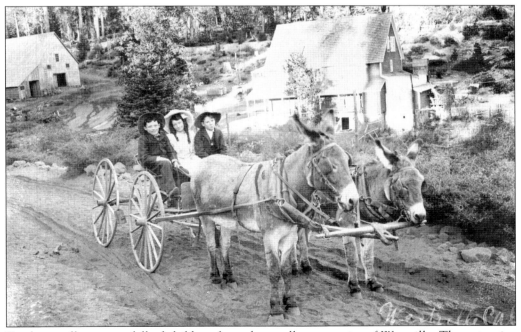

Donkeys pull a wagon full of children from the small community of Westville. The extensive note on the back of this postcard covers many different subjects, including the mention of a "Mr. Call" attempting to commit suicide by stabbing himself "all through his body."

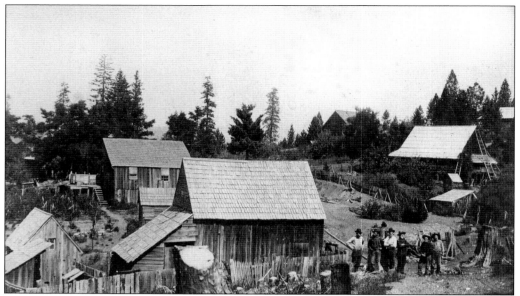

Residents of Last Chance pose for a photograph. Last Chance was another of the Forest Hill Divide mining communities that never had many residents. The town's name could have come from the idea that it was the last chance to find gold on the western slope of Sierra Nevada before going up over the crest and down the eastern side. (Courtesy of Placer County Museums Division.)

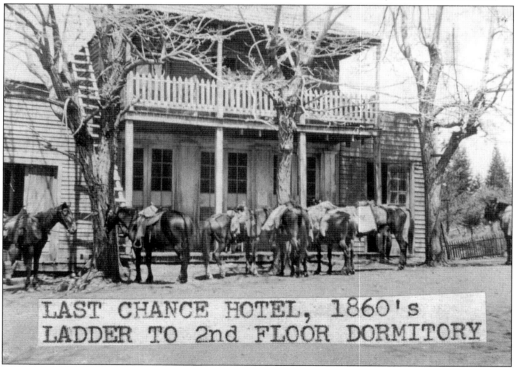

LAST CHANCE HOTEL, 1860's
LADDER TO 2nd FLOOR DORMITORY

A unique feature of the hotel in Last Chance was this quaint method for its customers to use in reaching the second-floor dormitory. (Courtesy of Placer County Museums Division.)

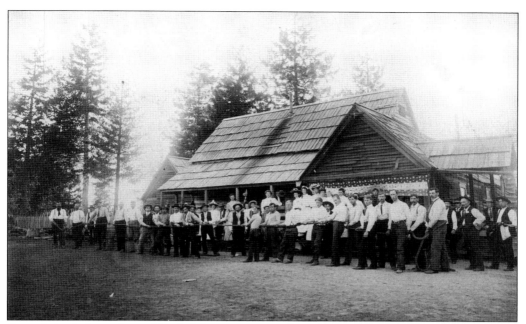

One of the Independence Day holiday events was the tug-of-war among the residents of Last Chance. (Courtesy of Placer County Museums Division.)

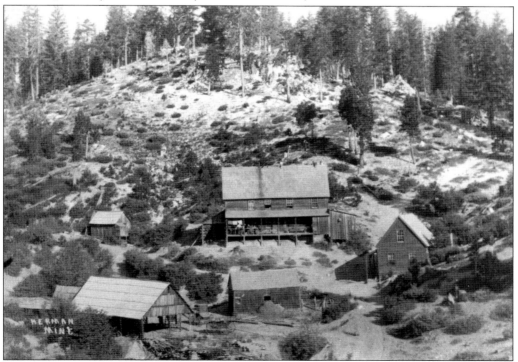

By 1907, fifty men worked at the Herman Mine. That year, three 20,000-pound steam-generating boilers were hauled, one at a time, by wagon from Auburn to the mine, 5 miles from the town of Westville. It was recognized as a very difficult feat by the local teaming fraternity.

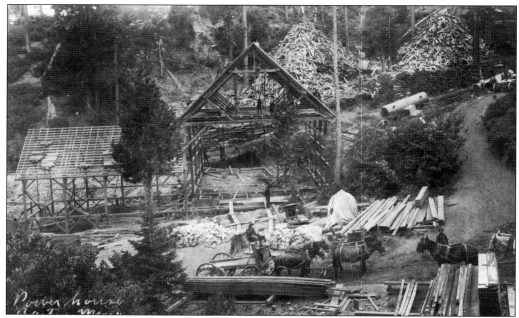

The two photographs on this page show the Barton Mine, named for Dr. Orren L. Barton, superintendent of mining operations at the Herman Mine. Dr. Barton was a medical doctor. The building under construction in the two photographs on this page was the mine's powerhouse.

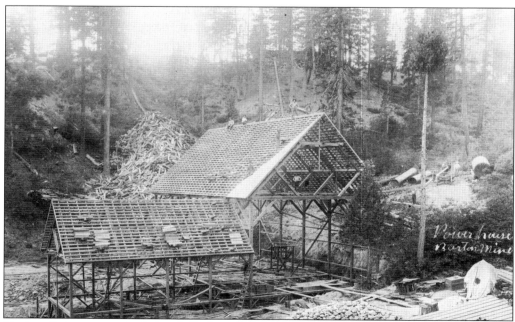

Notice all the cut wood piled on hillside in both pictures on this page. The wood was burned to heat the boilers for generating steam to compress air to drive the drills used in the mine tunnels. The compressors were very large and heavy. It was a difficult task to haul the compressors into these isolated mining locations.

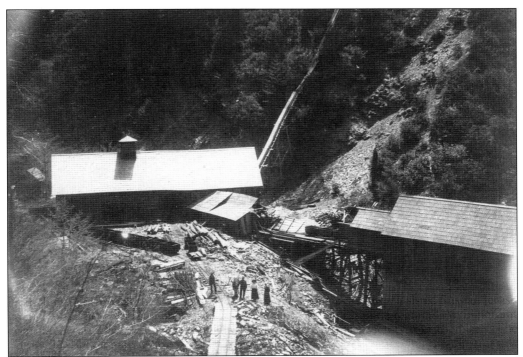

The ore processing buildings for the Red Point Mine are shown in this photograph. The Red Point Mine was also known as the Golden River Mine. The Herman, Barton, and Red Point Mines were typical of the gold mines founded on the Forest Hill Divide.

Red Point, Cal., Jan 1 1907

M. Red Point Mine

BOUGHT OF **H. W. McAULAY,**

DEALER IN

GENERAL MERCHANDISE.

Postoffice Address.
DAMASCUS,
Placer Co., Cal.

Aug	1	To	500 Blasting caps	3	75
"	"	"	100 # Powder	13	00
"	31	"	Horse Feede	15	00
Sept	4	"	Pick Handles	3	00
"	17	"	100# Powder	13	00

This receipt for purchases made for the Red Point Mine shows Henry McAulay's name as a dealer in general merchandise. Henry McAulay's brother George was the sheriff of Placer County from 1906 to 1918. George McAulay was also a director of the Placer County Bank starting in 1909 and was associated with that bank all the way through to World War II. He ended up as the bank's president.

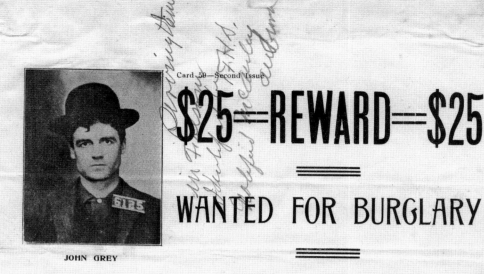

The note penciled at the top of this 1909 wanted poster states that John Grey has been captured and incarcerated in Folsom Prison and that Sheriff George McAulay has been so notified.

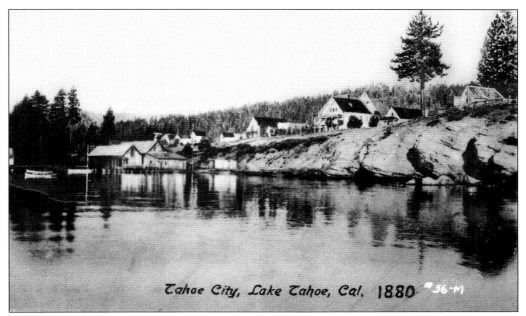

Tahoe City, Lake Tahoe, Cal, 1880 #36-M

A common image of Tahoe City around 1880 is indicative that most of the named locations at Lake Tahoe in the early years were resorts and not really towns. This was true not only in Placer County but all around the lake. (Courtesy of Placer County Museums Division.)

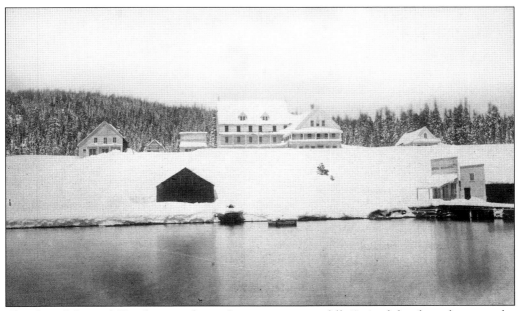

The Grand Central Hotel is seen here after a winter snowfall. One of the showplaces on the Tahoe shore from the 1870s through the 1890s, the Grand Central Hotel was billed as the finest establishment between San Francisco and Virginia City, with rooms for 160 discerning guests. It burned down in 1895. (Courtesy of Placer County Museums Division.)

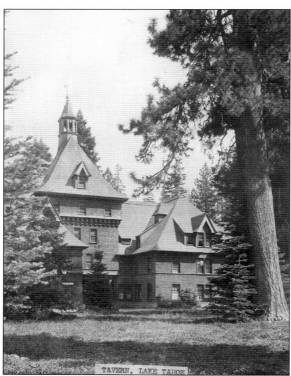

Tahoe Tavern started as a one-floor structure originally built in 1901. A 60-room annex was added in 1906. A second floor was added in 1907. The second floor included a bowling alley and ballroom with stage. Another wing to the lodge was added in 1925. The whole complex burned down in the 1960s. (Courtesy of Placer County Museums Division.)

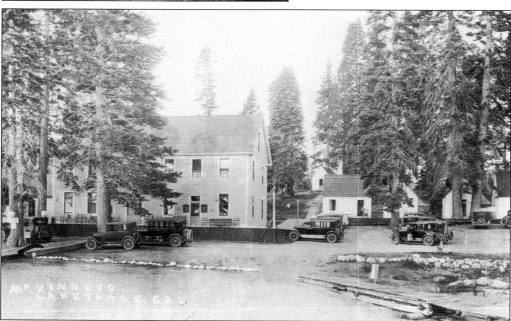

McKinney's at Lake Tahoe was later called Chamber's Lodge after David Henry Chambers, who bought the property in 1920. The name McKinney's came from original owner John Washington McKinney, who started the resort in 1863 as a simple hunter's retreat. Famed naturalist John Muir often stayed at McKinney's in the winter after the tourists and resort guests had departed.

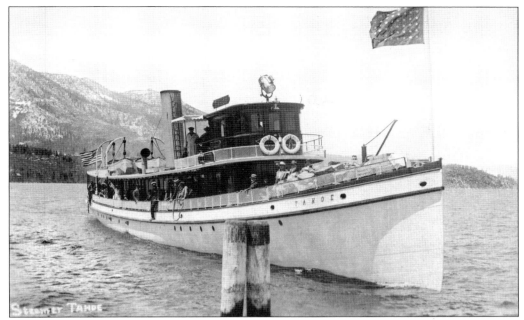

Small steam-powered boats were used on Lake Tahoe to move people, mail, dry goods, and produce from place to place. Almost every resort built on the lake had its own pier. This boat was appropriately named the *Tahoe*. (Courtesy of Dana Scanlon.)

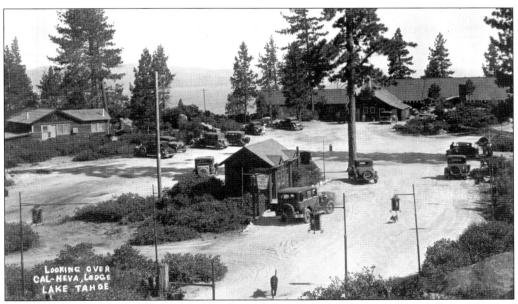

Chapter one began with Riego, which is located in the southwestern corner of Placer County. Cal-Neva is at the extreme opposite end of the county from Riego. Cal-Neva straddles the border between northeastern Placer County and the state of Nevada at Crystal Bay. This photograph is of the original Cal-Neva Lodge, which burned down in 1937. The rebuilt Cal-Neva was once owned by Frank Sinatra. It was put up for sale in 2009.

www.arcadiapublishing.com

Discover books about the town where you grew up, the cities where your friends and families live, the town where your parents met, or even that retirement spot you've been dreaming about. Our Web site provides history lovers with exclusive deals, advanced notification about new titles, e-mail alerts of author events, and much more.

Find Your Place in History.